PASTEL
Interpretations

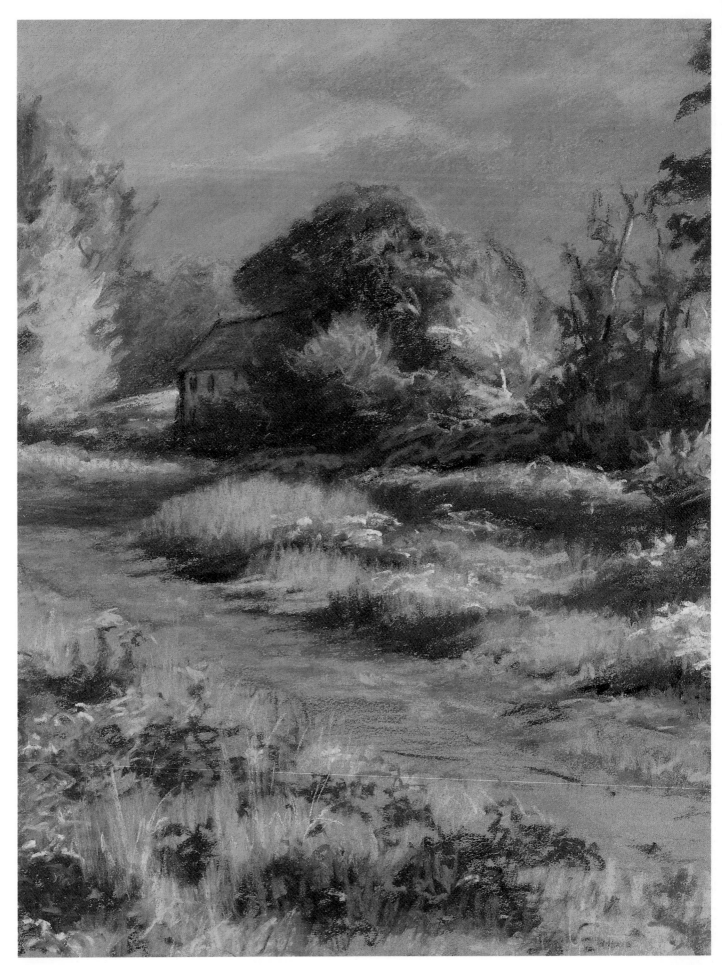

Detail from a pastel painting by Foster Caddell.

PASTEL
Interpretations

Madlyn-Ann C. Woolwich

NORTH
LIGHT
BOOKS

Cincinnati, Ohio

All photos © Madlyn-Ann C. Woolwich. Front jacket art by
Larry Blovits.

Pastel Interpretations. Copyright © 1993 by Madlyn-Ann
C. Woolwich. Printed and bound in Hong Kong. All rights
reserved. No part of this book may be reproduced in any
form or by any electronic or mechanical means including
information storage and retrieval systems without permis-
sion in writing from the publisher, except by a reviewer, who
may quote brief passages in a review. Published by North
Light Books, an imprint of F&W Publications, Inc., 1507
Dana Avenue, Cincinnati, Ohio 45207. 1-800-289-0963. First
edition.

97 96 95 94 93 5 4 3 2 1

Library of Congress Cataloging in Publication Data

Woolwich, Madlyn-Ann C.
 Pastel interpretations / Madlyn-Ann C. Woolwich.
 p. cm.
 Includes index.
 ISBN 0-89134-475-6
 1. Pastel drawing. 2. Drawing from photographs. I. Title.
NC880.W66 1993
741.2'35 — dc20 93-16081
 CIP

Edited by Kathy Kipp
Designed by Clare Finney

DEDICATION

With gratitude and love to Mom and Dad, whose
love and devotion inspired me to search for excel-
lence. With love and admiration to my husband Joe,
for his constancy, love and support. Love to my chil-
dren—Kim, Stephanie and Ali, the flowers in my
garden of life, for their courage, love, honesty and
pursuit of an enlightened life.

ACKNOWLEDGMENTS

To my teachers, Ida Libby Dengrove, Mary Sheean,
Wolf Kahn, Lillia Frantin, Herb Edwards, Sid God-
win, Peter London, Seymour Segal and Barbara
Nechis, for always going the extra mile. To Flora
B. Giffuni, PSA, charismatic founding and present
president of the Pastel Society of America, whose
talent and vision gave all pastel artists an opportu-
nity to exhibit in New York. Thanks to the Guild of
Creative Art, Shrewsbury, New Jersey, my home
base, for being an inspirational source for artists and
students.

To Libby Fellerhoff, who gave me a chance to
shine as "Member of the Issue," *North Light* maga-
zine.

To Carole Katchen, whose fine articles have
helped us all, for generously including me in her
beautiful book, *Creative Painting With Pastels*.

Many thanks to Greg Albert, Rachel Wolf and
Kathy Kipp, the wonderful editors at North Light
Books—and Marty Munson of *The Artist's Magazine*.
Your outstanding talents, helpfulness, availability
and inspiration make writing a pure pleasure.

The artists in this book—surely the most tal-
ented group anywhere—made this a most enjoyable
and inspirational experience. To my many students
in classes and workshops, I wish continued joy in
creating art. To all artists working in pastel, who
constantly reinvent and interpret this beautiful me-
dium, this book is an invitation to go further and
really reach your goal.

CONTENTS

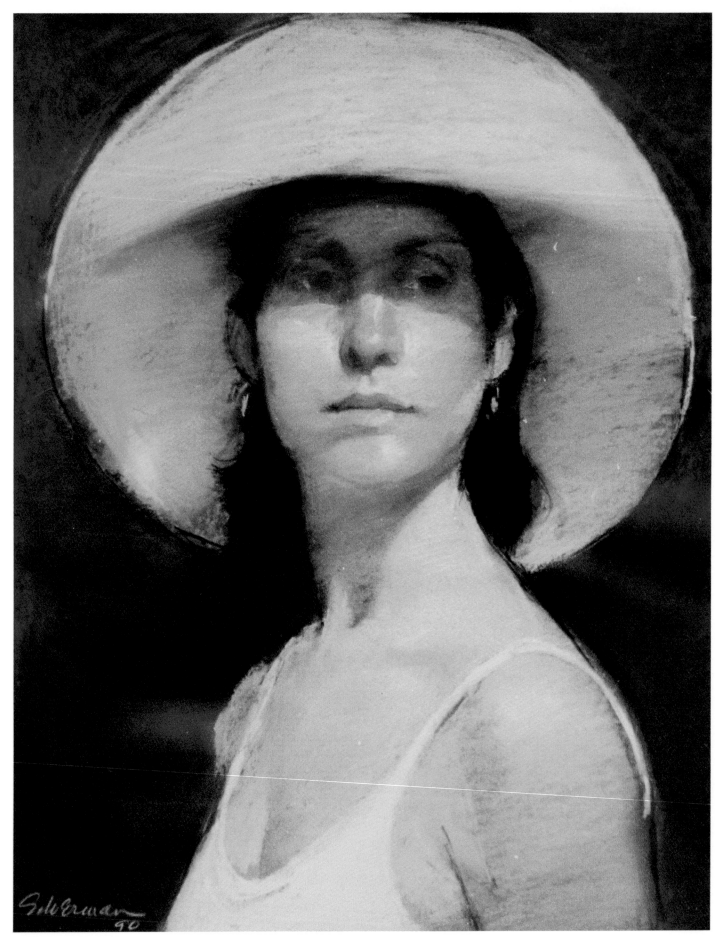

THE SUNHAT
Burt Silverman, pastel on paper, 14″ × 17″. Private collection.

INTRODUCTION

Pastel is the most wonderful and malleable medium imaginable. It promotes passionate and sensuous application. There is a magical immediacy about it: Nothing is added to dull the luster of the beautiful jewel-like color. As an artist, I think, and even dream, in pastel.

Pastel generates such ardor in its followers partly because its use is so individualized. There are many surfaces to choose from, many different types of pastels themselves, and many ways to apply them. This includes the option of mixing pastel with other mediums such as water, turpentine or watercolor paints, to name a few.

In my work as a teacher of classes and workshops, I was constantly amazed by the inventiveness of artists using the pastel medium. I was also fascinated to realize how much we can learn from each other and our different approaches, both in technique and concept.

That's how the idea for this book was born. I thought it would be exciting and enlightening to see how several master pastel artists would create a completely original pastel painting, each working from the same source.

For each source, I decided to use a black-and-white photograph. Within each chapter the "chapter artists" will work from the same black-and-white print. I tried to cover a broad range of traditional subject matter in my choice of source photos, including landscapes, figures, portraits, seascapes, still lifes and flowers.

I intentionally did not choose very "artistic" photographs. I simply wanted the photo to be a reference from which the individual artists could create their own paintings. The advantage of using black-and-white, rather than color, photographs is two-fold. First, it is very easy to see and interpret tonal values in black and white; and second, the lack of color forces the artists to make their own interpretations . . . and variation and creativity are what this book is about. At the end of each chapter is a "gallery" showing additional finished paintings by the artists.

Pastel Interpretations explores the internal vision and working technique of eighteen of the nation's best pastel artists. They, as all artists, are constantly gathering information, perfecting skills and learning new techniques.

Most of the contributing artists are also teachers. The dream of every teacher is to spark and maintain creativity among his or her students. This book invites you to share these artists' explorations. Study the many ways of seeing and interpreting. Investigate the many new techniques and materials presented. Learn to change light patterns, introduce backgrounds, crop out parts of the source photo, give atmosphere or ambiance to the scene, or even reverse night and day.

I hope you will embark on this journey with us to learn or improve your pastel techniques, gather more information and master new working methods. Whatever your skill level, you can express your own individuality, and make your own interpretation, in pastel.

RURAL LANDSCAPES
USING TOOLS AND MATERIALS

There is a veritable banquet of pastels, papers, supports and surfaces. Prepared surface supports include Masonite, foamboard, canvas, board and paper. These can be prepared with various surfacing compounds made from gesso, latex, pumice and marble dust, diatomaceous earth and vegetable fibers. Whatever surface you choose needs to have tooth and the ability to hold the pastel particles.

Art stores have amazing numbers and brands of pastels for sale. There are pastel pencils such as Carb-Othello; hard pastels such as Nupastel, Conté and Sakura; and soft pastels that come in increasing degrees of softness from Grumbacher and Rembrandt to Gira-

ult, Schmincke, Sennelier and Rowney. All have their own individual characteristics and colors, and experimentation will develop your favorites. Many artists make their own pastels, and handmade ones such as Arc-en-Ciel are prized by artists.

STORING AND USING PASTELS

Pastel storage promotes inventiveness. Artists store their pastels in fishing tackle boxes, revolving compartments, carpenter's cabinets with thirty or forty small drawers, art boxes, large divided tables that sort pastels into areas of shades and anything else that promotes efficient location of the desired color.

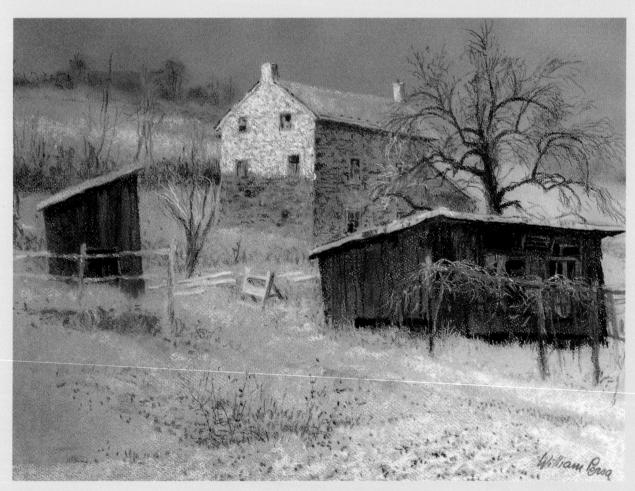

OLD HOUSE ON APPLEBUTTER ROAD, William Persa, pastel
on Ersta sanded paper, 19″ × 23″. Collection of
George Ringhoffer.

Most artists keep the pastels in use separate from the rest in some form of a palette. The artist may set the "palette" pastels in rice or cornmeal to keep them clean while in use. The list is endless, but the bottom line is that the studio gets dusty, pastels get dirty and the artist gets both dusty and dirty.

THE PASTEL LANDSCAPE
Nature provides all the subject matter for a potential landscape. Often, working outside can overwhelm the senses. It is hard to simplify the landscape without losing its essential character. It is often helpful to use a cardboard viewfinder to isolate a portion of the landscape. This helps clarify the subject and eliminates extraneous detail.

SEASON AND MOOD
Once the space is divided and the landscape organized and edited, the following must be decided: mood or ambiance, degree of sunlight and shadow, ground conditions and effects of seasons. An artist can manipulate these factors for variety. Summer includes bright, strong light, flowers and the intense greens of trees and bushes in full foliage. Spring and fall exhibit great changes in the color and thickness of the vegetation. Winter casts its own capricious magic with changes in the water to form snow and ice, and leafless trees to decorate the foregrounds and distances of the landscape. In every season the sky, ground and water need careful observation.

THE ARTISTS' INTERPRETATIONS
A pastel may be organized around a predominant color or color scheme. This promotes *visual energy*, defined as the impact of image and color upon the viewer. The artists in this chapter, working from the landscape photograph below, use a variety of creative methods to paint strong, colorful, dynamic interpretations. The photograph, filled with superfluous details and lacking a clear focal point, tested the organizational and artistic skills of all.

Judy Pelt uses color, texture and the addition of cows to create her bucolic scene. Frank Zuccarelli uses luscious light patterns and seasonal change to show surface and textural changes. Adding a strong architectural note and profound changes to the photograph, William Persa creates a moody color composition. Elizabeth Mowry establishes strong ambiance, seasonal color and vigorous surfaces in her two textural renditions. Anita Wolff combines tactile vigor and illuminating light and figures to her impressionist version of the landscape.

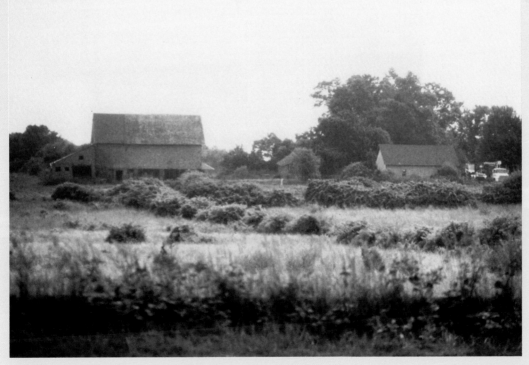

ON THE WAY TO NEWPORT

JUDY PELT
Develop the Rhythm of the Landscape With Texture

Pelt chooses the versatile surface of a Fredrix pastel canvas to create her textural and colorful landscape. Using mat medium and pumice she creates a textured surface that will be receptive to a variety of strokes. She adjusts the composition by adding distant hills, putting a slight roll in the land, dropping and turning the barn behind the crest of the hill, and adding five cows.

With a combination of Nupastels and a variety of soft pastels, including Girault, Sennelier, Schmincke and her own homemade pastels, Pelt works in warm color glazes. With the season established as autumn, she is able to include glowing colors and strong textures. She uses compressed air to remove pastel and make minor changes. For framing she recommends a simple gold frame with an off-white 3″ liner and a gold fillet between the painting and liner.

STEP 1: Pelt decides to raise the horizon and add some cows. She sketches her initial drawing with Nupastels on Fredrix pastel canvas.

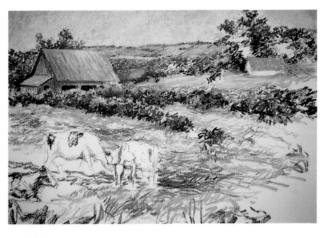

STEP 3: "I introduce some English Reds in the background and warmer colors in the foreground. The groundwork strokes are done in a choppy manner to develop texture and give a feeling that the cows might have trampled the grasses."

STEP 2: "The first two aspects I consider are the season and the weather. Fall will give me colorful grasses and a misty atmospheric day. I begin to establish the sky with cool colors. A directional line is created by using misty reds for foliage, and indigos and violets for the roofs."

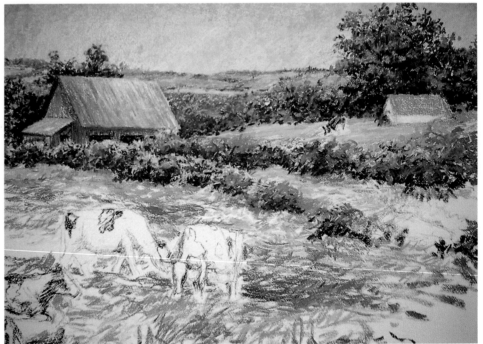

STEP 4: "I continue to develop the grasses with warm siennas, and put orange and olive in the far field. At this point I am still assessing size and placement of the cows. I decide to add a distant hillside dotted with fields at the extreme left."

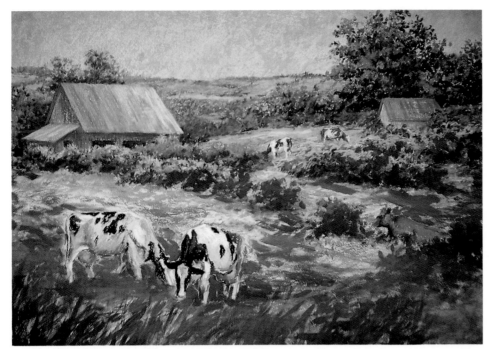

STEP 5: "I block in the cows' anatomy with purple-grays and light caput mortuum reds. Using light and dark shapes, I aim for a reasonable facsimile of a milk cow. All lights are done with colors other than white, such as light blue, yellow or pink. The black spots are a combination of darkest green-blacks, indigos and purple-blacks."

STEP 6: "Several changes are made, including the angle of the roof and placement of the cows. I add the final strokes of purple, pink, yellow, light orange and warm siennas in Nupastel. This darkens the front to match the values in the photo."

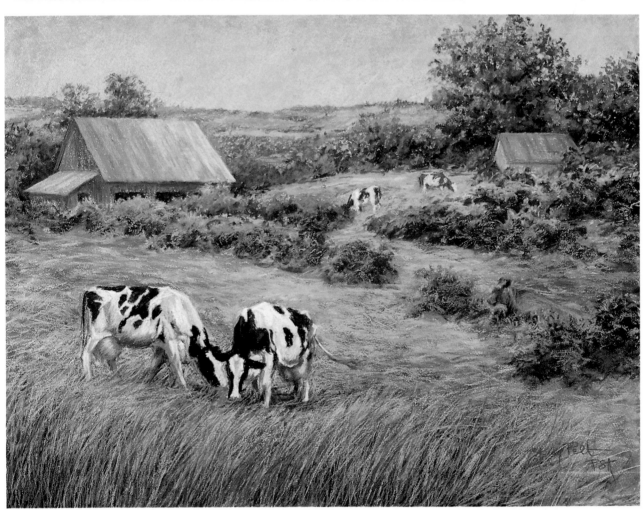

ON THE WAY TO NEWPORT
18″ × 25½″

FRANK ZUCCARELLI

A Light Pattern Adds Important Texture

Using "color comps" to make artistic decisions and adhering to a five-value study, Zuccarelli creates his impressionistic paintings. He tries not to rely on the same strokes, colors or materials, because he wants to infuse a personal quality in each pastel.

This New Jersey artist usually makes outdoor sketches and photographs on location and completes the work in the studio. Each picture is infused with his emotional response to a particular site. He likes working on moody landscapes, capturing the light patterns and textures of the scene, and the colors and atmosphere that impart a uniqueness to each pastel.

To frame this pastel, Zuccarelli suggests two different color combinations: Alpha mat board in #8504, shadow blue with a white liner and a blond molding with gold to enhance the warmth of the scene, or Alpha board #8511, Seamist, with a white mat for a liner.

STEP 1: "With a felt-tip pen I divide the space and add a pond and trees. The small pond is intended to draw the eye into the picture."

STEP 2: "With charcoal on white paper, I create a design of darks, halftones and lights. I develop interesting light patterns for textures that will develop later."

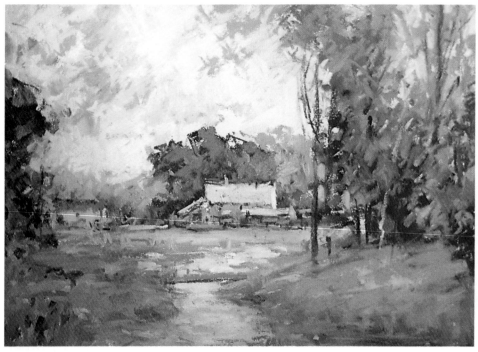

STEP 3: "Working with Nu-pastels, I make color comps on the same type of surface that will be used for the finished pastel. Detail is postponed as colors are juxtaposed and harmonized. The barn is sharply focused and I warm the trees for contrast against the cool background. Forward and middle distant planes are strengthened."

STEP 4: "I prepare a 24″ × 30″ Crescent watercolor board with my own gesso and pumice mixture. With a round #1 bristle brush I outline the subject with acrylic washes and continue to develop the colors of the composition in broad forms. I aim the color relationships for a sunny effect."

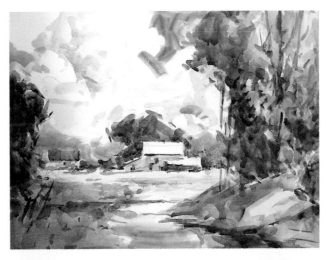

STEP 5: "Using the flat side of the Nupastels, the first application of pastel is put in as an undercoating. This is the underpainting that will still show through in the final stage."

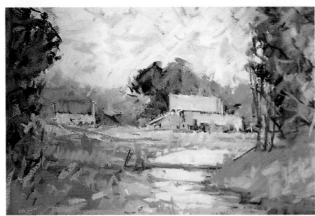

STEP 6 (BELOW): "Working toward a finished statement, I put a second layer in the sky, using the same colors as on the color comps, but adding a creamy white in the light areas. After lightly spraying with Krylon fixative, I use an orange glaze on the wooded areas. With bold strokes I give importance to the wooded areas. The calm surface of the water is left undisturbed. Fallen limbs are added for interest, and a small footbridge is simply stated. This final layer contains the most profound changes and restatements; adjustments of value, color, temperature and texture are worked again. The light pattern becomes the dominant theme."

ON THE WAY TO NEWPORT 18″ × 24″

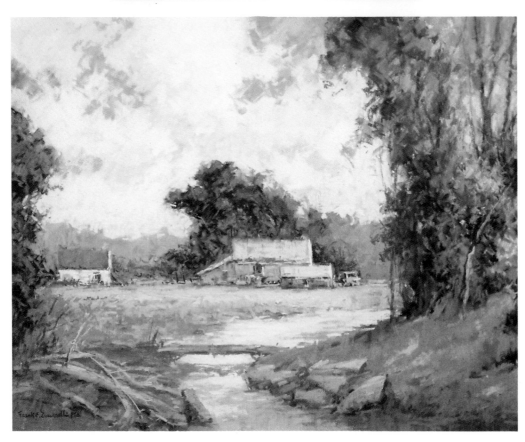

WILLIAM PERSA
Adding Architectural Elements to the Picture

Persa decides to work on Ersta 7/0 grit German sanded paper, using the following materials for his interpretation of the rural landscape: Nupastels, Carb-Othello pastel pencils, Weber-Costello Hi-Fi grays, Holbein pastels and Krylon fixative. He works out his intended values in a series of thumbnail sketches.

He considers the photograph unexciting, shot at the wrong time and with uninteresting barn and house structures, and decides to make profound changes in the landscape. He plans a dramatic approach, with low sunlight coming from the left, a low-key palette, balanced darks and lights and the addition of an old stucco silo and a flock of pigeons.

Persa lives on a farm in rural Pennsylvania, and he gives interest to the composition by adding personal objects, such as the rusty plow. His knowledge of the land and seasons adds authenticity and authority to his art, and helps him plan an autumn scene. He suggests framing this pastel with a triple white mat and rustic, wood molding for the best visual effect.

STEP 1: "I draw a few thumbnails with old barns, stone cellars and a round cement silo. I decide to use a fall scene for the bright color and use a low bright sun from the left of the composition. Then I make a few miniature studies on a small piece of black pastel paper."

STEP 2: "With the sky drawn in with blue Nupastel and blended, I work on the silo with preliminary color notations. I add background autumnal areas and barns. Slight color suggestions are added to foreground areas."

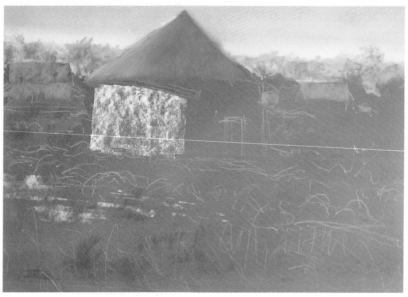

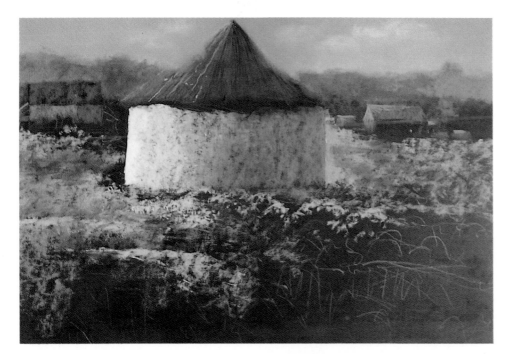

STEP 3: "I start work on the middle-distance grasses, add color to the right shadowed area of the silo and refine the silo roof. With a chamois, I remove some of the light blue sky. The sunlit silo is intensified and I develop details all over the painting."

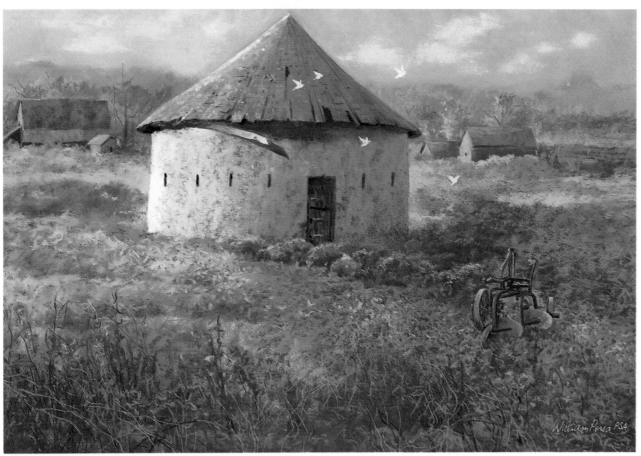

STEP 4: "I add the pigeons, making one the center of interest. After much refining, all areas of the farm composition are emphasized. The decision to promote a 'farmy feeling' results in the addition of an abandoned, rusty, antique plow to enhance the silo as a focal point. My slide and photo collection of almost everything related to farms provides me with a personal interpretation."

ON THE WAY TO NEWPORT
11″ × 16″

ELIZABETH MOWRY

Basic Materials Can Give Life to Foliage: Two Views

Using an L-shaped mat to simplify the picture, Mowry decides to make minimal changes to the scene or the values. She states, "I believe that I interpreted this scene expressionistically."

Before beginning, Mowry spends much time thinking, planning and visualizing the completed work. She explains, "I select a palette that will contribute to the mood I want to portray. Even so, throughout the painting, I am still open to the surprises and the flow. I can identify with the photograph immediately and want to add that 'end of the day quiet' feeling that is part of my environment in the Hudson Valley. I decide to incorporate some of the late fall colors because I feel that they will promote the feeling of the landscape."

In her second version of the same photograph, Mowry puts the scene farther away, developing the right side and leaving the left side as an open and dominant sky area. The edges are softened and the contrasts diminished. The picture is dominated by atmosphere and the feeling of changing weather. The colors are cool and peaceful.

She recommends framing with a creamy white linen mat and a simple gold or silver frame for both renditions of the rural landscape.

STEP 1: "I tape Ersta Starke sanded paper (P400), cut 18″×24″ size, to a piece of sanded plywood. Two pieces of newspaper are placed between the Ersta and the plywood. After doing a simple sketch with a Carb-Othello pencil, I begin laying in the sky with soft pastels—gray-blue at the top and pink at the bottom. Mars violet helps pull the colors together, and establishes the mood for the painting."

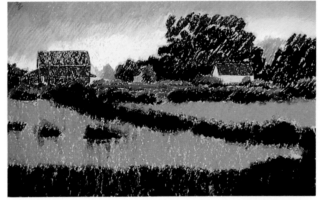

STEP 2: "I apply the first layer of soft pastel with broad diagonal strokes, using dark olive and sienna for the foliage. Carb-Othello pastel pencils help push color into the sky and distribute it in large areas with crosshatch strokes. I allow my tools to work spontaneously with me."

STEP 3: "I unify masses by holding a pastel pencil by the end and dangling it back and forth to mix and soften edges. The pink light in the sky helps in the development of the middle ground. Ochres and cool purples are added to give a cooling effect."

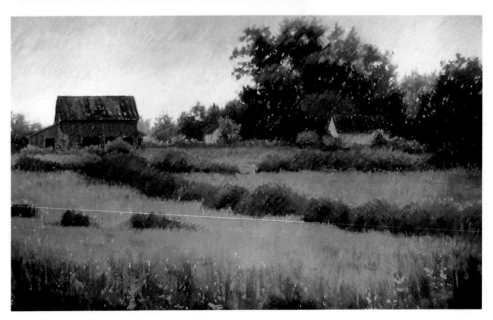

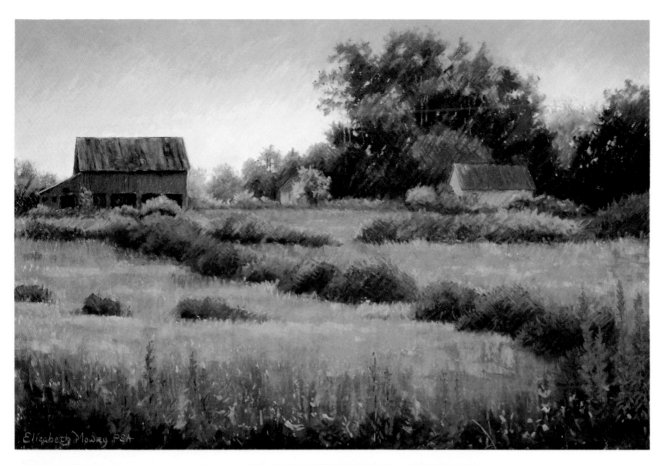

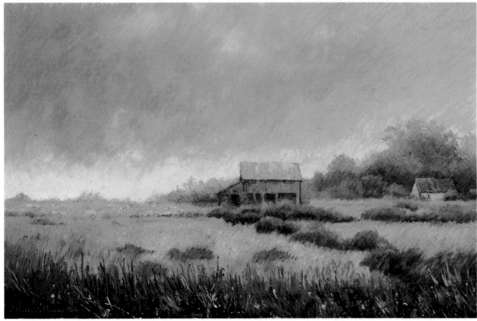

STEP 4: "Final details include adding windows, removing the tiny attached roof on the right of the barn, and lowering the bush in front of the building, as well as the hedgerow so that it joins the foreground. Dried field flowers and dried loosestrife in the foreground repeat the colors of the barn. I unify the entire painting and try to hold back from overdoing it."

ON THE WAY TO NEWPORT
14″ × 22″

VERSION 2
Mowry chooses a more open interpretation of the same photograph to create her second expressionistic painting of the landscape.

ON THE WAY TO NEWPORT
II, 14″ × 22″

ANITA WOLFF
Thickness of Application Determines Emphasis

For her impressionistic version of the landscape, Wolff chooses Margulies board for a working surface. Deliberately working with a full palette, much like the French Impressionists Monet, Renoir and Pissaro, she demonstrates how emphasis can be controlled through application techniques. A rough surface holds pastel and allows for all types of effects, including layered applications for a very painterly look.

Wolff decides to use a square format, so she positions the building to the right, leaves out rows of plants and growth, drops the ground plane and adds two figures and a dog. The random texture of her working surface is instrumental in creating light patterns, which establish the drama and mood.

Wolff uses hard and soft pastels, and sprays the successive preliminary layers with fixative. She uses light and medium values thickly to make objects move forward. She constantly reinforces darks that may be lost in the working process. When finished, she recommends putting this pastel in a natural oak frame with a wide, warm middle-gray mat, or in a wide, non-ornate gold frame with a linen liner.

STEP 1: "I divide my 12″ × 18″ paper into fourths to make thumbnail value sketches. Four possible approaches present themselves: (a) berry vines with undulating shapes and forms, (b) a cloudy overcast evening with enlarged barns and minimal bushes, (c) an interesting autumn sketch with pumpkins in the foreground. I choose (d), the larger sky area with people and a dog."

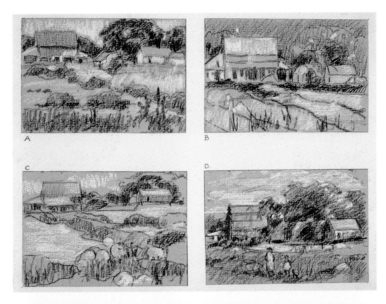

STEP 2: "On a handmade surface with random textures, I use compressed charcoal to block in the open color scheme. This is to be an evening scene with a restful mood. The colors used are blue, blue-violet, blue-green, violet and red-violet. Reds and yellows add complementary excitement to the cool color scheme. I will keep the darks thin and the lights thick. I block in warm darks in front and blue in the background for distant perspective."

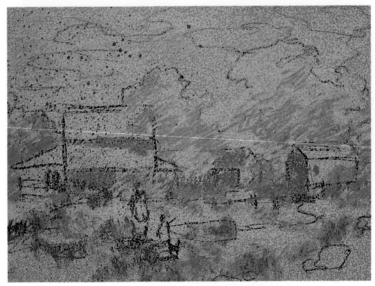

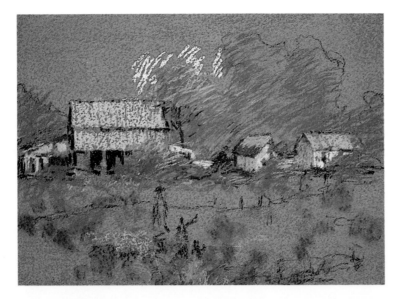

STEP 3: "Using Rowney black pastel, I strengthen the line drawing and darken the trees, ground and bushes. I begin the tree foliage with hatching, open-color strokes. I locate and place the lightest and brightest color on the focal point — the barn."

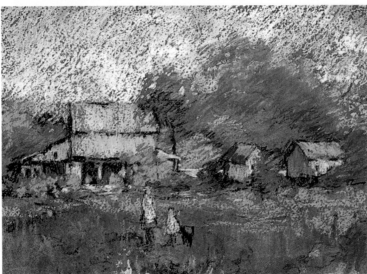

STEP 4: "Varying color changes and warm and cool grays on the building give me a sense of excitement. The middle ground of foliage gets an application of warmer colors. The figures and the dog are placed in, and sky holes are added."

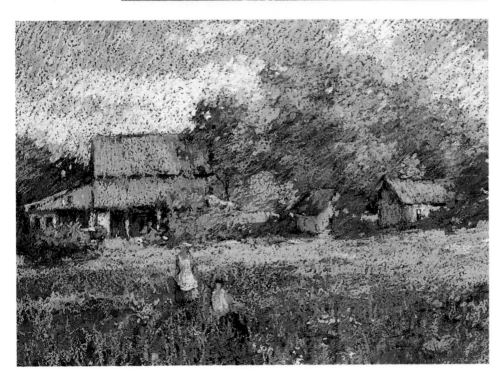

STEP 5: "I paint in a suggestion of flowers and weeds, and the sunlit areas of foliage get a thicker application of lights. I put darks in the foreground and field. By darkening the front of the field, I keep attention on the barn."

ON THE WAY TO NEWPORT
10½″ × 13″

GALLERY OF LANDSCAPES

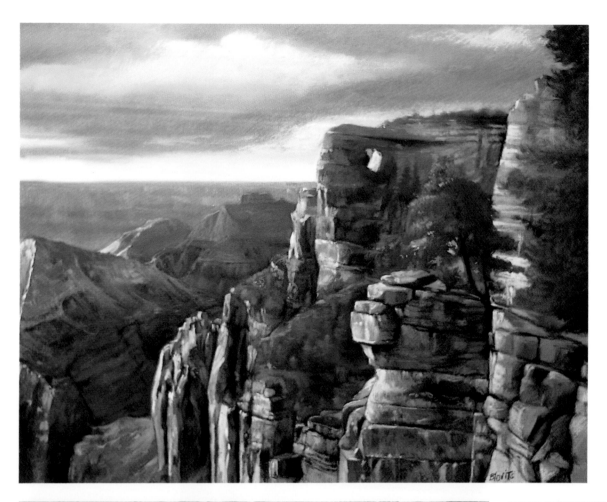

ANGEL'S WINDOW, Larry Blovits, pastel on sanded board, 19″ × 25″. Collection of the artist.

Blovits's pastel of southwestern rock structure shows the vivid combinations of complementary colors and textures that import realism to the scene.

MCCULLOUGH GARDEN #5 Frank Zuccarelli, pastel on pumice board, 18″ × 24″. Collection of MCC Corporation.

Zuccarelli's garden demonstrates the vivid use of colors and textures that give vibrance and energy to the subject matter.

SUNLIGHT ON THE ROCKY
BROAD, Claire Miller
Hopkins, pastel on paper,
10" × 14". Collection of Mrs.
Jim Dozier Adams.

Hopkins's pastel captures
the viewer's eye with the
sunlight patterns, and the
rough, craggy appearance
of the rocks.

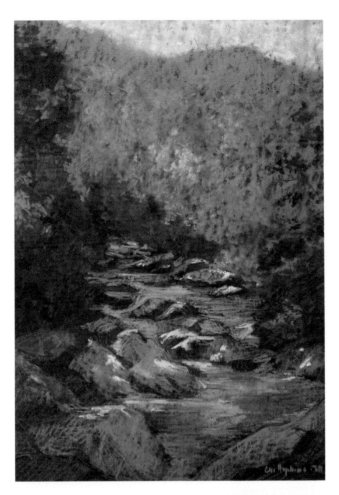

GREAT PINES, Alan
Lachman, pastel on pumice
board, 20" × 24". Collection
of the artist.

Lachman's colorful pastel of
a group of pine trees is a
good example of how a
rough surface can help
highlight the textural ap-
pearance of the subject.
Many layers of color are visi-
ble, which helps describe the
subject well. Bright colors in
the foreground are repeated
in the sky for a connected
look.

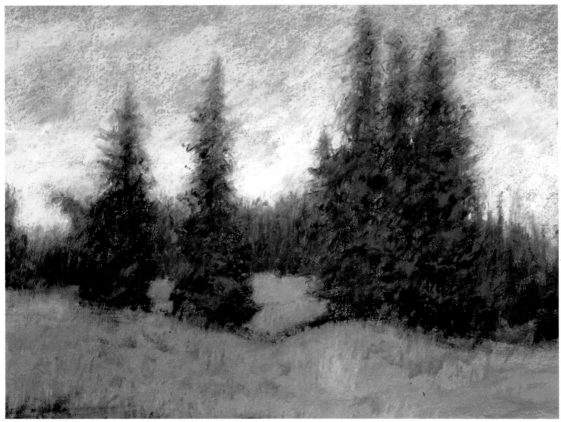

TWO

THE FIGURE

ARRANGING LIGHT AND SHADOWS

Vibrant lights and darks give strength and artistry to a picture. In a well-designed composition, pictorial elements of light and shadow are played against each other to define form and space. The patterns of light and shadow determine the internal structure of the image, and color is only a consideration after values of dark and light are established. Shadowed elements generally recede, diminishing in importance and distance. Light gives impact and forward movement to the person, object or scene.

PATTERN POWER

Most artists know the importance of arranging shadow patterns. Frequently, massing the shadows to make dark and light patterns is more important to the picture's success than the pictorial elements.

This pattern helps unify the picture. Reflected lights and highlights may need to be altered. In fact, both shadow and light shapes can be changed and rearranged to facilitate a strong composition before introducing color.

LIGHT AND SHADOW WORK TOGETHER

Two types of shadows must be considered. *Form shadows* occur as the object turns away from the light. These shadows are flowing, have malleable, soft edges and help describe the object's form. *Cast shadows* occur when the object blocks the light. The silhouette shape of the casting object defines the shadow shape. A cast shadow can anchor and solidify the image. Cast shadows have harder edges than form shadows.

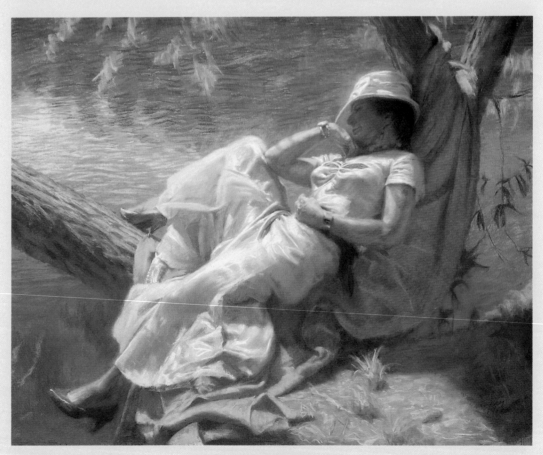

OLYMPIA, Bob Graham, pastel on paper, 25″ × 35″.
Collection of the artist.

Form and cast shadows act independently. As the light moves, the cast shadow moves and the form shadow of the object changes. When painting outdoors, capturing these moving shadows can be a formidable task. Massing in the shadows quickly and sketching the important elements can capture the scene for further refinement.

USE FIVE VALUES OF LIGHT AND SHADOW

Many of the artists in this book compose their work with a five-value structure. The basic approach involves using a highlight, a light value, a halftone (halfway between the lightest and darkest tones), and two values for shadow. Reflected color from adjoining objects, highlights containing some color from the light source, and shadows containing warm and cool color values are all simplified to promote unity in value and composition. Although light and shadow cannot be separated from value and color, they nevertheless need their own consideration.

Light and shadow patterns are never more adroitly used than in the painting of the clothed figure. A high degree of competency and artistry is necessary to combine the curved surfaces of the human body, the subtle blending of shadows, the bouncing of light and reflection and the connecting halftones in a successful pastel painting. A group of clothed figures adds the problem of combining and connecting the figures to each other and their environment. Planning and carrying out strong light patterns and gradations of colorful shadows require careful planning and a thorough knowledge of the human body.

THE ARTISTS' INTERPRETATIONS

The working photograph, "The Conversation," challenged the four chapter artists. Given a photograph with somewhat flat lighting and little form or cast shadow, each had to make important decisions about establishing the light source and creating a shadow pattern. A further challenge was to design a background and integrate the figures into it. Working from an assigned perspective, each artist created a powerful and personal pastel painting. Tim Gaydos creates two different compositions from the same source. The first is an intimate scene of the two figures in the original environment. His second, done in vibrant values and long shadows, places the two figures in a beach scene. Alan Lachman crops the scene and comes in close for a sense of intimacy between the figures. Jill Bush paints a lush impressionistic landscape that fosters the gestural connection between the figures. Claire Miller Hopkins, calling her painting *Carolina Twilight*, moves the scene to North Carolina and renders it as a glowing, backlit scene with rim lighting.

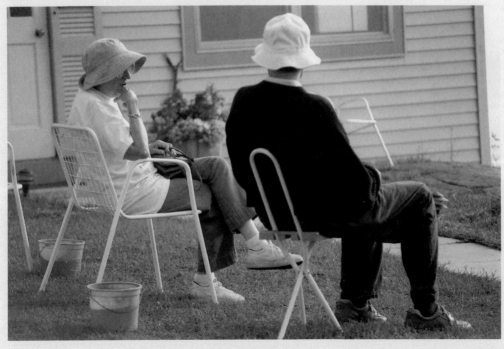

THE CONVERSATION

TIM GAYDOS
Making a Focal Point With Color and Value: Two Views

Working on dark gray Canson Mi-Teintes paper, with Rembrandt, Sennelier and Grumbacher pastels and an unlimited value structure, Gaydos composes his composition with intensive color contrasts.

He defines the focal point as the woman's head and assigns her hat a bright yellow color to contrast it against the cool background. The reds and yellows give the figures cohesion and move them forward in space. Gaydos says, "Lights and darks are very important in my work. I particularly like to use shadows for design purposes."

Gaydos frequently moves compositional elements around in his work. This is one reason that pastel is his ideal medium. He likes the exciting col-

ors and energy of the visible strokes, and the duality of drawing and painting at the same time.

Using a larger piece of Canson paper and the same basic materials, Gaydos composes a second pastel from the same source photo and titles it *Conversation by the Sea*. He changes the colors in the figures to bring them forward and creates a new background. He infuses the second version with rhythm and harmony, and creates iridescent lights and long colorful shadows.

He suggests framing either composition in a silver metal frame with a 3½" medium gray mat and a ¼" white inner liner, or a gray wood outer frame with a white 3" liner.

STEP 1: "In my initial preparatory sketch, I make changes in the window in the background, bring the figures closer together and indicate a cast shadow on the building."

STEP 2: "I modify the values of the figures for balance. Reds and pinks in the clothing help bring them closer together and bring them forward. The woman in the yellow hat becomes the focal point. I lighten the background, particularly between the figures, to focus on their interaction."

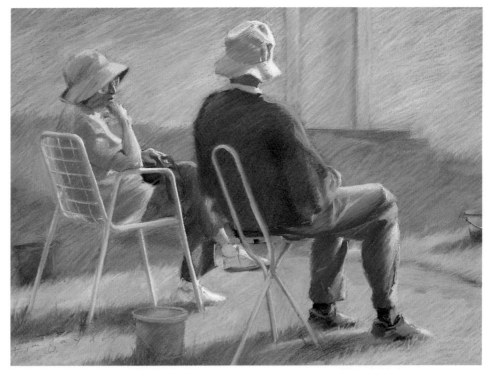

THE CONVERSATION
18" × 24"

VERSION 2
STEP 1: "With charcoal on Mi-Teintes paper, I pull the figures closer together to create a dominant image. I place the scene near the sea."

STEP 2: "I move the chairs, darken the clothing, and unify the figures into the larger image for greater impact. I add a headland to vary the low horizon line. While finishing the grass, chairs and everything else, I change the direction of the shadows, moving the cloud to the right of the man's head. I finish and crop the painting."

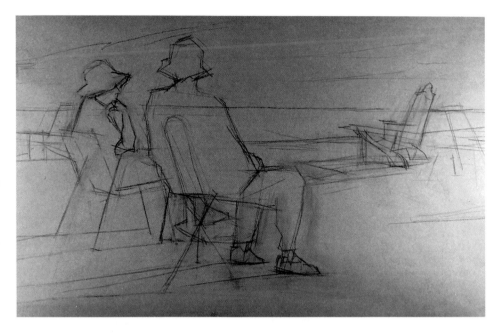

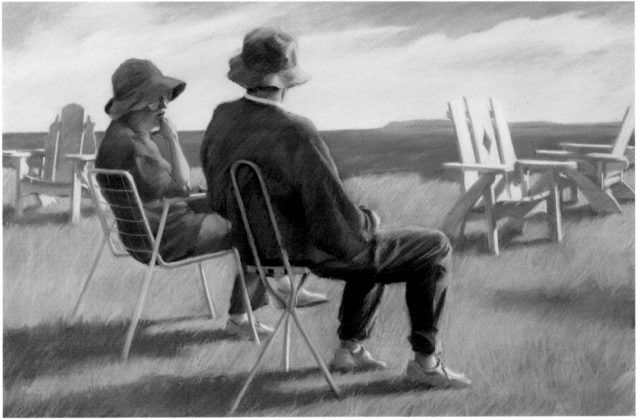

CONVERSATION BY THE SEA, 22″ × 32″

ALAN LACHMAN

A Limited Value Structure Can Create Intimacy

Lachman, a pastel artist from Pennsylvania, works on mat board, which he prepares with gesso and marble dust. His pastels include Nupastel, Sennelier and Schmincke. Working in a loose and painterly way, he tries not to make premature decisions about the composition. He explains, "If I lock in immediately from the beginning, then all I am doing is rehashing what I already know. The statement then becomes too much of a generalization, and what I want to talk about is the uniqueness of the moment."

To keep a fresh approach, Lachman works large with a limited value structure and moves figures slightly to establish intimacy. He feels constrained because he did not take the photograph and lacks the emotional connection of being at the scene. He notes the awkward placement of the figures and feels challenged to use every means possible, both subtle and obvious, to create conversation and intimacy; he arranges colors, values, lights and shadows to enhance this concept.

His suggestions for framing include a decorative frame and mat to enhance the pastel, or a neutral frame and mat that just allow the painting to be.

STEP 1: "I lay in the values as they relate to the figures, designing them to flow through the painting."

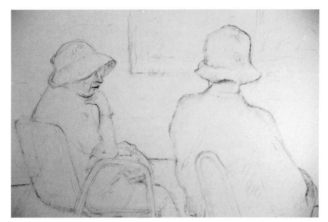

STEP 2: "Making a line drawing, I try to place things in the right spots. What I am trying to say motivates everything that I do in a painting."

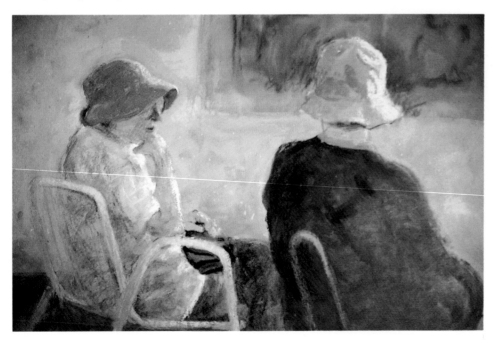

STEP 3: "On an acid-free museum board, surfaced with marble dust, I begin to lay in values using an acrylic wash. Using strong and vibrant lights helps me make artistic decisions. In succession I lay in the darkest darks, mix complementary colors for grays and then put in lights. The painting begins with Nupastels and progresses to layers of soft pastels of various kinds."

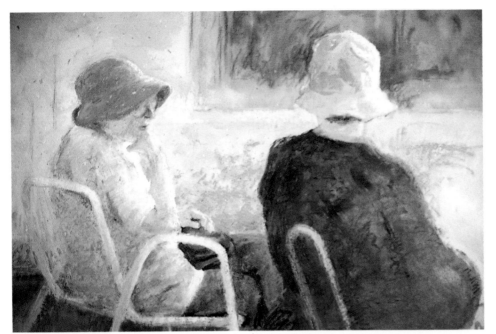

STEP 4: "Darkening darks, I break up the edges and paint one edge into the other. I try to create dynamic tension between the figures and add flowers to create intimacy."

STEP 5: "I pull the areas together and enhance the luminosity of the warm colors. I keep trying to quietly relate the values, shapes and colors. I feel that the piece turned out mildly impressionistic."

THE CONVERSATION
24" × 36"

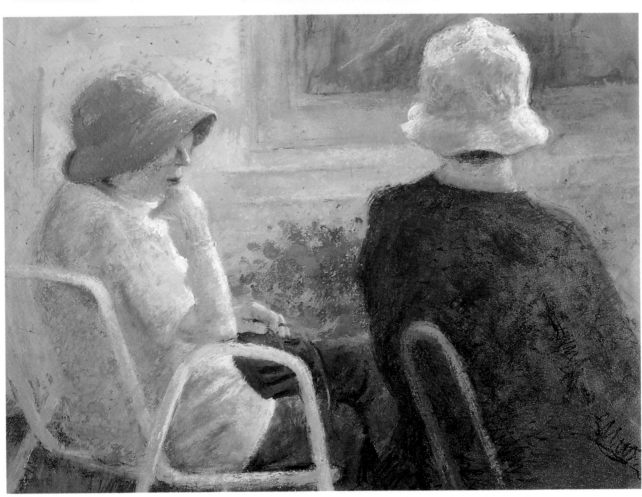

JILL BUSH
Capturing the Gestural Connection With Reflected Lights

Bush makes multiple value studies to determine perspective lines, make compositional changes and assign color. Much of what could be potentially troublesome is solved before finishing the initial drawing. When she is satisfied with her preparatory work, Bush lays in her charcoal drawing on toned and stretched pastel cloth. She states, "I believe that my interpretation is primarily impressionistic. I try to remove distracting elements and focus everything on the conversation. I also want the color of the painting to be subservient to what is going on. I see some symbolism in the picture and decide to keep the man's sweater black and absorptive (as the man

is the listener) and the woman's blouse white and reflective (as the woman is the speaker)."

Bush finds that the photograph's major problems are the distracting background, the distance between figures and the overwhelming darkness of the man's sweater. She sets out to create reflective lights, soften edges and portray an imaginative scene.

She suggests two ways of framing her pastel: either a soft gold frame about 1½″ to 2″ wide with a ¾″ wood liner wrapped with white linen, or a soft gold frame 1″ to 1½″ wide with a 2″ wood liner wrapped with white linen.

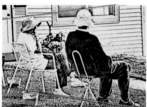
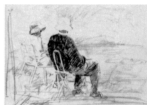

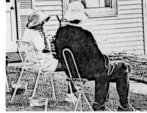

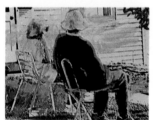

Bush photocopies the black-and-white photo in three ways, solving some problems by establishing perspective lines, moving figures closer, and experimenting with color relationships.

Small charcoal thumbnails show some possibilities for a changed environment—at the beach, on the porch and in a park.

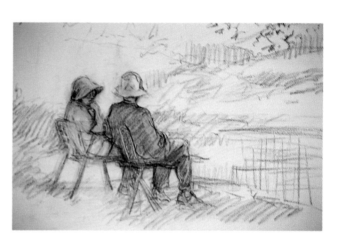

STEP 1: Bush chooses the park for the background. With the two figures moved together, the gestural connection is made. "I rough in the sketch in vine charcoal on pastel cloth, locating figures gesturally at first until proportions and placement suit me. Pastel cloth is forgiving and allows me to correct. I use Blair spray fixative to isolate the charcoal from the watercolor layer to follow."

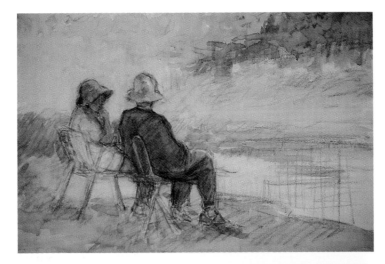

STEP 2: "I underpaint with watercolor on white pastel-cloth, which needs toning. I assign specific local colors, mostly in the medium value range."

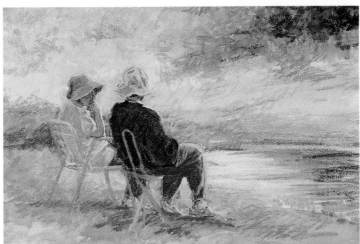

STEP 3: "First strokes of pastel are laid in, and colors are developed for a good foundation. With a country scene, I want to use olives and earthy greens because I feel that they will lend a soft, quiet, intimate quality. I use red-violets to bounce into clothing and background, gray-violets to temper background colors."

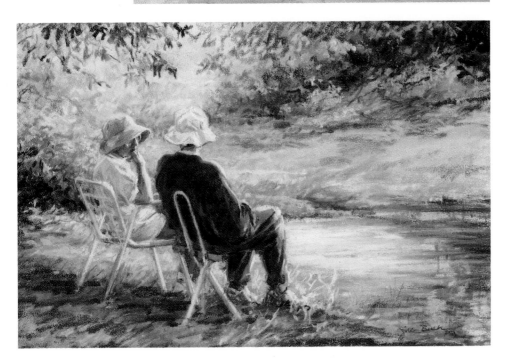

STEP 4: "With a multitude of bright lights and colors, I begin developing reflecting light sources. I scumble over some of the yellow-greens with Schmincke bluish-violets and bluish-greens. With careful attention to the hats and other surfaces that reflect the blue sky, I try to build a vibrant picture. I create a canopy of leaves around the figures and deepen the value of the ground beneath them with a glaze of fine charcoal. I intensify the pink hat and brighten hues of the other colors."

THE CONVERSATION
16″ × 24″

CLAIRE MILLER HOPKINS

Manipulating Background to Change a Composition

Intending to create early evening light from memory, Hopkins adds a Carolina landscape. She states, "The busy elements of the landscape and the solid shapes of the figure give me the difficult problem of combining two paintings."

Hopkins tries to simplify shapes and focus on the most important part of the painting, allowing the rest to fade and become sketchy. She tries to avoid overstatement and repetition. This is a busy painting that represents a step outside her usual way of working. On sanded paper mounted to acid-free foamboard, she underpaints with pastel, using odorless turpentine or paint thinner to establish a pastel wash. Subsequent pastel layers are built on this wash, with great attention to negative spaces and object and color relationships.

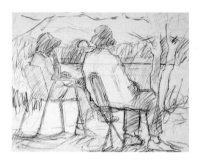

STEP 1: "Having made some pencil sketches first, I begin my drawing in charcoal, pulling the figures closer and placing them near a pond at evening. The man's figure appears larger and is centered, but I hope to treat the spaces around him in a way that will make the placement comfortable."

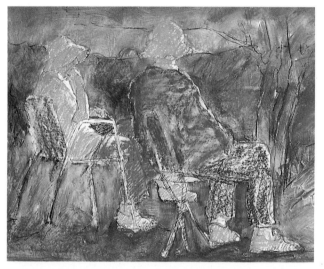

STEP 2: "I begin a rough underpainting using the flat side of a broken soft pastel. If it is to be a warm area, I scrub in cool pastel, and scrub warm color where there will be a lot of cool shadow. After applying pastel, I brush on odorless paint thinner to create a color wash."

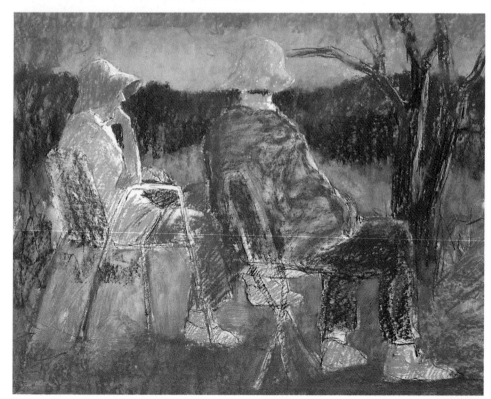

STEP 3: "I begin to spot color around and define large shapes. I try to make a good space division behind the figures, making areas of sky, water and foreground dissimilar in size."

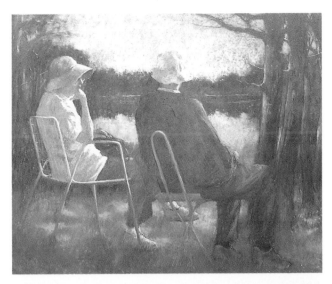

STEP 4: "Redesigning the clothing, I put the figures in the late afternoon sun. I introduce more color, putting red into the woman's pants so that the man's sweater will not dominate. I correct the angle of the arm on the male figure, introduce local color into the chair area, mass shadow and create a careful distribution of lights."

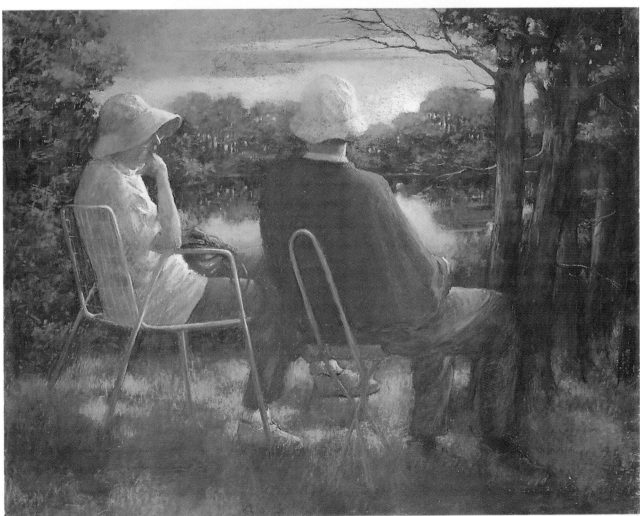

STEP 5: "My main interest in working from this photograph has been space. Since intimate conversation is the subject, manipulating the space to support the subject has been the goal. With so much going on in the painting, simplification of shapes seemed essential. Rim or edge lighting allows me to unify shapes, keeping darks simple. Lights on the edge of forms are the descriptive areas. With minimum lighting on trees, a few sunlit spots describe the area sufficiently."

THE CONVERSATION— CAROLINA TWILIGHT 22″ × 27″

THE FIGURE IN GROUPS
Defining Important Connections Using a Limited Palette

Connections exist between light and shadow, people and the environment, people and other people, color and texture, and the relationship of colors within a composition. A limited palette may be approached in various ways: high-key, low-key, or a limited palette confined to primary colors of red, blue and yellow and perhaps white and black. It may be the selection of a limited number of pastels in any chosen color combination. Sometimes it will be complementary and analogous colors, such as one of Monet's favorite combinations—an array of pinks and reds, a complement of green and split complements of reddish-purple and blue-green.

The choice of colors in a limited palette may also be selected for a particular subject. On these two pages we'll see how four different artists, using limited palettes, colorfully interpret the black-and-white photo of a group of fishermen on Monhegan Island, Maine.

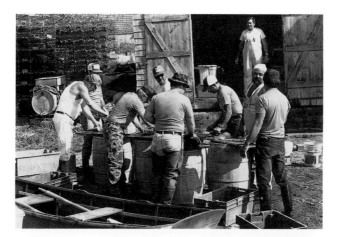

THE COD CUTTERS: FISHERMEN OF MONHEGAN ISLAND

WENDE CAPORALE, using glowing colors and a high-key painting, develops a light-filled picture. The connections of exciting lights and shadows and a feeling of camaraderie are evident.

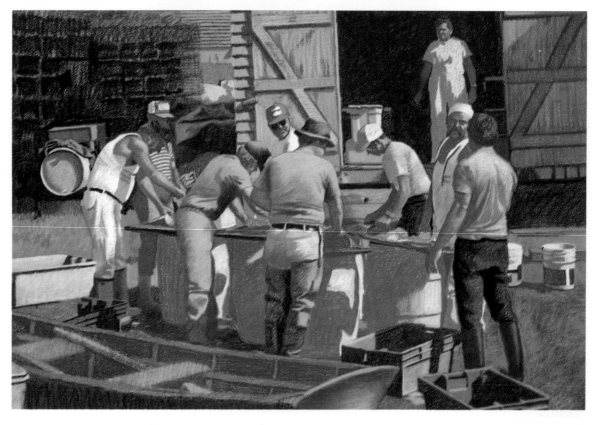

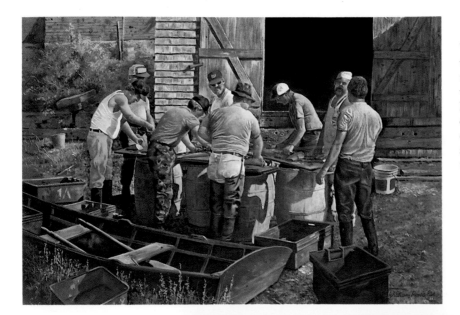

WILLIAM PERSA works with a low-key painting and uses appropriate colors and values to render a striking low-key palette in which the clothing colors and the quietly glowing light patterns add illumination and texture to the material.

BOB GRAHAM, with an unlimited value system and strong color, crops the number of fishermen to develop a more intimate, small group.

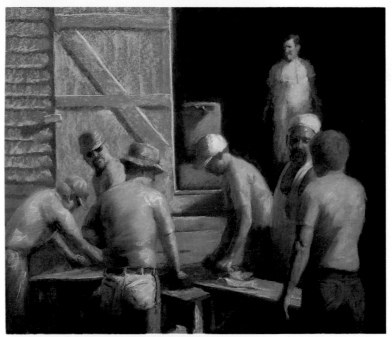

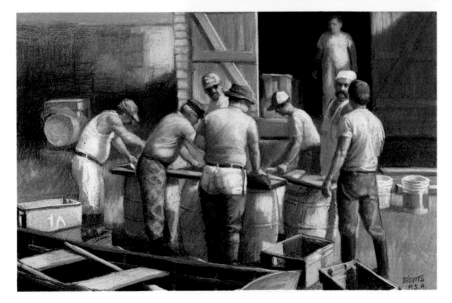

LARRY BLOVITS, eschewing his usually vibrant colors, develops a moody painting with a limited value structure, giving an entirely different light to the environment and picture. The dominant darks subdued by the cool colors focus the attention on the fine details of the figures.

GALLERY OF FIGURES

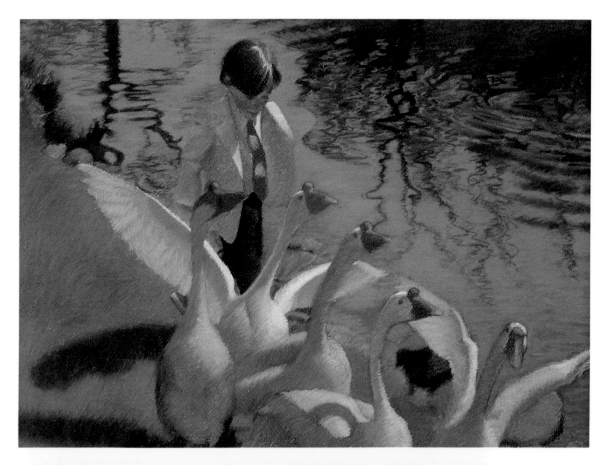

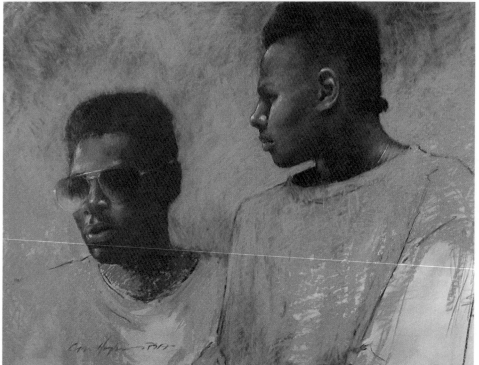

BOY AND GEESE, Wende Caporale, Canson mounted board, 21″ × 29″. Private collection.

Caporale's round, soft edges and glowing colors are perfect for this child's portrait in an environment. The light patterns capture the diverse textures of hair, clothing and feathers. The innocence and beauty of childhood is the hallmark of her work.

SOUTHSIDE V, Claire Miller Hopkins, pastel on sanded paper, 22″ × 27″. Collection of the artist.

Hopkins shows the simplification of shapes, important negative spaces and constrained color values that are evident in her portrait and figure work.

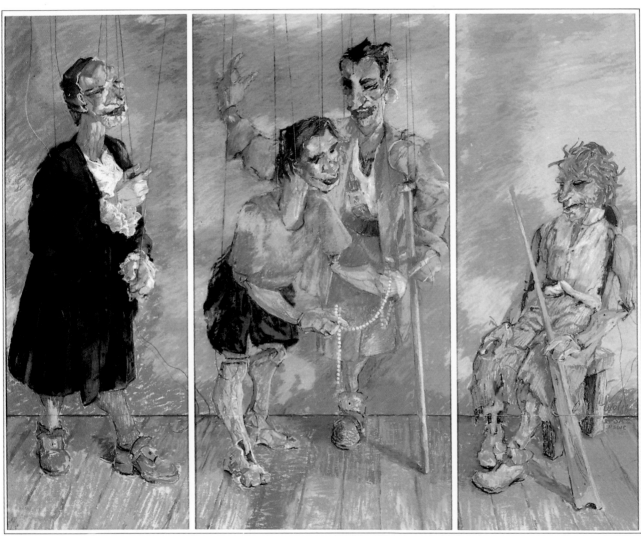

MARIONETTES, Anita Wolff,
pastel on board, 22″ × 28″.
Private collection.

Wolff, with a muted, high-key palette, paints famous California marionettes as a group. The individual panels appear almost allegorical, a visual statement of individuals smiling and trying to be ingratiating. The interconnected patches of background color connect the scene in a harmonious way.

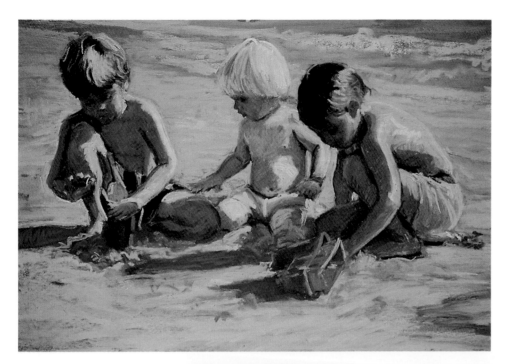

DAY AT THE BEACH, Jill Bush, pastel on paper, 22″ × 28″. Private collection.

With a high-key palette of bright primary colors and warm, iridescent lights and shadows, Bush creates a bright, textural scene. The overlapping shadows, touching figures and color use provide strong connections between the figures and the beach environment.

TREKKING TO WHITEHEAD, Madlyn-Ann C. Woolwich, pastel on pumice board, 28″ × 38″. Collection of the artist.

With a palette of complementary red and green, orange and blue, Woolwich creates a luminous scene of a group heading up the path to explore the cliffs of Monhegan Island. The light and shadow patterns connect the figures, and the colors of the figures are echoed into the background.

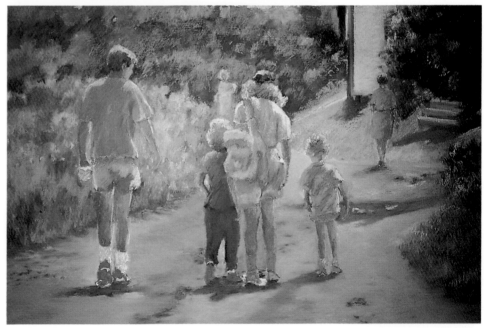

YOOPER DIALOGUE, Larry
Blovits, pastel on paper,
18″ × 24″. Private collection.

Blovits's colorful scene of
conversation shows a lim-
ited palette in a low key,
with strong dark passages
that provide important
value connections. The
overlapping and intercon-
nections of the people give
intimacy to the scene.

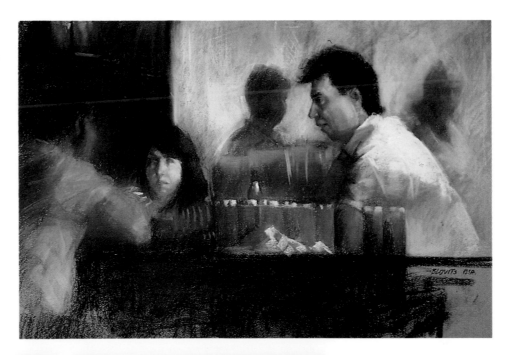

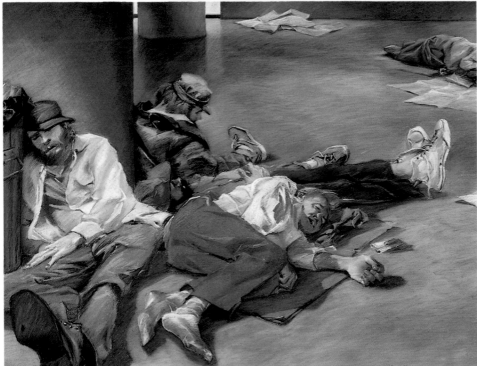

TERMINAL NIGHTS, Tim
Gaydos, pastel on paper,
30″ × 42″

Gaydos, portraying the
homeless of New York City,
infuses his city portraits
with angst and despair. A
strange beauty develops
with his use of complemen-
tary colors, vivid light pat-
terns and textural delinea-
tions. This creates a
powerful work.

SEASCAPES

APPLICATION AND EMPHASIS

A seascape speaks to the inner being and is undoubtedly one of the most appealing of all subjects. Almost everyone has been enthralled by watching the sea: the exciting, brilliantly colored scenario of waves crashing against rocks, sun shining, sea gulls flying and the radiant interplay of lights glinting from the rocks and water. When the sea is tranquil, it is a peaceful, serene scene. The sea has many moods.

THE PASTEL SEASCAPE

The colors and cadence of the sea are among the most vivid images we encounter: beautiful, vibrant lavenders and purples; sparkling yellow-greens, aquas, turquoises and viridians; and a range of blues from palest clear blue to the deepest cobalts and ultramarines. Rocks and cliffs are siennas, umbers, grays, blacks and reddish-oranges. Foam is not only white, but when reflecting the sun, sky, a storm or clouds, is white, yellow, pink, lavender, gray and blue. The pastelist has an almost unlimited number of pastels to portray the colors and actions of the sea. Every nuance of a tint or shade is available to reflect the scene.

The sea can be captured using varied applications of hard and soft pastel on paper, board, pastel cloth, sanded paper and Masonite. A rough surface seems to portray the dramas of light and dark, giving credibility and life to the subject. The mastery of edges is never more necessary than when an artist re-creates a soft and splashing wave against a craggy rock. No medium better depicts the ephemeral qualities of the ocean.

The sky is also an important aspect of seascapes. The stormy, cloudy and sunny effects of the sky can be brought to life using dots, strokes, lines, textures, broad patterns and color fields.

Seascapes, as in any other landscapes, use hard edges to promote emphasis. The quintessential ex-

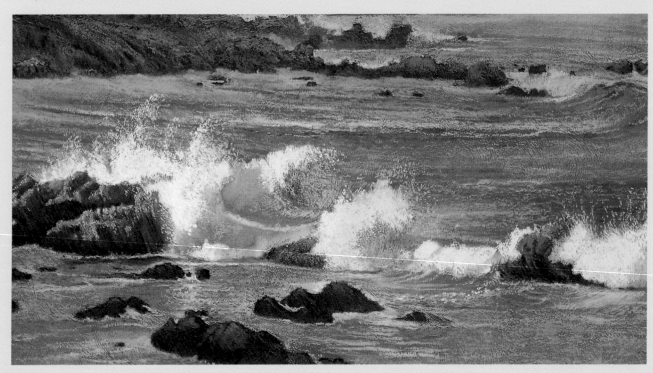

MORNING, ASILOMAR, Margot Schulzke, pastel on sanded board, 16" × 22". Private collection.

ample is a sharp, angular rock with a wave crashing against it, and spray going in all directions. In a pastel rendering, some of the wave color will be in the rock, and some of the rock's color will be visible in the water. The edges will be softened and blended in some places. Hard-edged waves will approach and soft ones will recede. The process of applying pastel in seascape painting involves reiterating the dictum that for every hard edge there is an opposing soft edge. Learning to manipulate these edges promotes confidence and facility.

GIVING AUTHENTICITY TO YOUR PASTEL SEASCAPE

Seascapes may be lit from the back, side or front, depending on the sun's direction or the artist's choice. One wave, object or person should become the focal point. The other parts of the picture should lead your eye to the focal point. This is usually emphasized by the conjunction of the darkest dark against the lightest light and often the hardest edge. All of the other waves will recede, become bluer and

diminish to the horizon. The air contains dust and moisture, and as things go into the distance, they lose transparency, the color cools, the outline is less distinct and the size diminishes.

THE ARTISTS' INTERPRETATIONS

The artists in this chapter use a variety of rough surfaces, and hard and soft pastels and pencils. Drawing with charcoal, underpainting with acrylic washes, and spraying and layering the pastel for texture and fluidity, they capture the power and the glory of the ocean.

Frank Zuccarelli paints two different mood portraits: a colorful autumn sea with side lighting, and a turbulent sea that brings the rock formation up close and creates a rolling, chaotic background of waves. Mary Sheean creates a humorous Victorian scene of three fully dressed figures in front of the rock and surf formations. The man's shoes are in the water. Her second piece is a traditional seascape with a vertical plane of light adding a mystical quality to the piece.

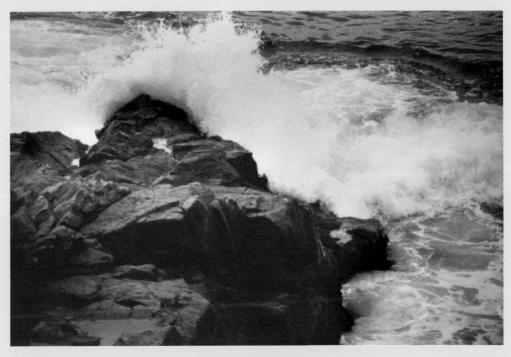

STORM AT PEMAQUID

FRANK ZUCCARELLI
Using Artistic License to Create Interest: Two Views

Using impressionistic realism, Zuccarelli portrays the beautiful abstract patterns and the power of the sea with a distinctly personal technique. For the first interpretation of the photo, he spends most of a day planning his composition, using color studies and two-dimensional patterns. With a five-value structure, he allows for variations at each step. He feels that all picture problems can be successfully addressed by using a resolute plan of values and color to achieve the intended mood. He explains, "An artist establishes where the viewer looks by how the darks and lights are handled."

In the second version, Zuccarelli brings the rock formation forward. He portrays a stormy, somber atmosphere. Cool colors dominate this version, except for the rock area, where warmth provides a contrast against the sea. He explains, "The major difficulty is in redesigning the whole composition. Past experiences at sea allow me to visualize the threatening sea mood."

For framing he recommends the first version be framed using all archival materials—a V-cut, shadow blue, outside Alpha board mat (3½" to 4") with an inner white liner and a 1" gold wooden frame. The second version would be enhanced by using a 2" frame with a rustic finish and a 2½" neutral mat with a white liner.

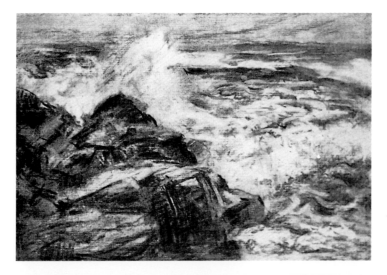

STEP 1: "I establish the value patterns in charcoal to set the mood of the seascape. The rocks are kept hard and jagged, and the spray edges are soft and diffused. The direction of the spray is changed to accelerate the splashing and whipping patterns. I place the lightest light in the spray."

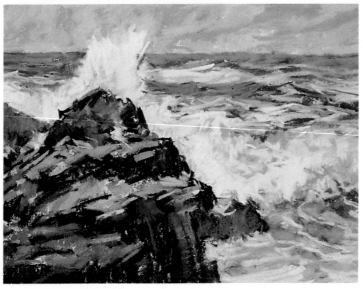

STEP 2: "I make a color study with Nupastel sticks to establish a bright mid-afternoon mood with strong lights and darks. Side lighting is emphasized. The sky reflects pale blues and grays, and a warm glow is effected by including some faint pinks and violets. A cloud bank is placed at the horizon, and a cloud sweeps down from the upper right to the focal point."

STEP 3: "I prepare a fine, gritty surface on a Crescent double thick watercolor board prepared with Hyplar gesso and powdered pumice and a little water. With a gray Othello pastel pencil, a rough but careful outline is drawn on the board. These areas are left loose and modifiable as the painting progresses."

STEP 4: "With careful attention to my original values, I apply broad washes of watercolor with Hyplar paints. The colors of the sea are brushed in, as are the shapes of the surf, spray and foam. Light values of pink, blue and violet are washed into the sky and in the roll of the surf. Light, warm colors are brushed into the horizontal planes of the rocks. I am not concerned with edges at this stage."

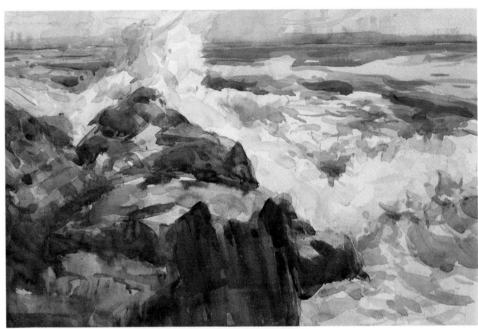

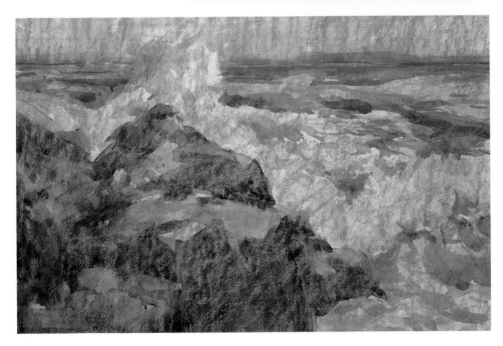

STEP 5: "When the watercolor washes are dry, light tints of pastel color that will still be visible in the final stage are begun. An underpainting is made using Nupastel blues, greens, pinks and violets."

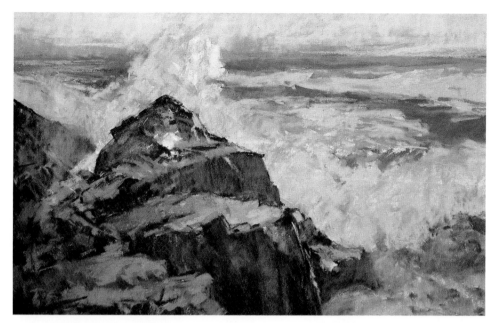

STEP 6: "I place darks in the rocky shore and the shadow sides of the rocks. The jaggedness of the rocks is accentuated by short, choppy strokes. Careful attention is paid to edges, concentrating on the sharpest area where they are silhouetted against the water. The surf is done with diffused soft edges to avoid a hard appearance."

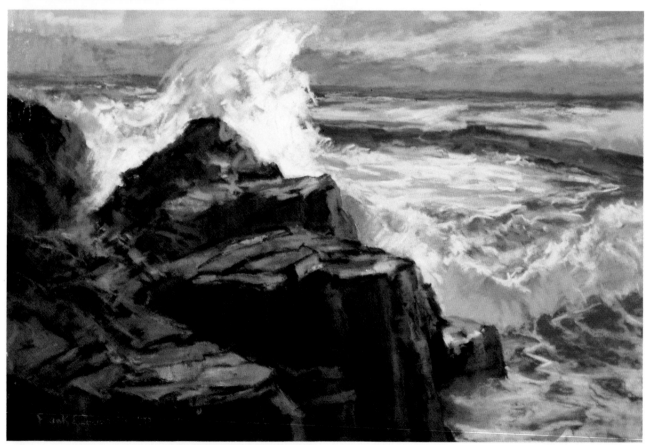

STEP 7: "I spend a great deal of time adjusting values on the surf and developing shadow sides of the large spray using light blue and pale greens. I continue to work, spraying and glazing layers of color. Edges are carefully handled, with the sharpest edges being the points of the rocks against the spray. I refine the rock planes, abstract shapes and crevices to establish ruggedness. A final glaze of light blue makes the rocks glisten."

STORM AT PEMAQUID
12" × 18"

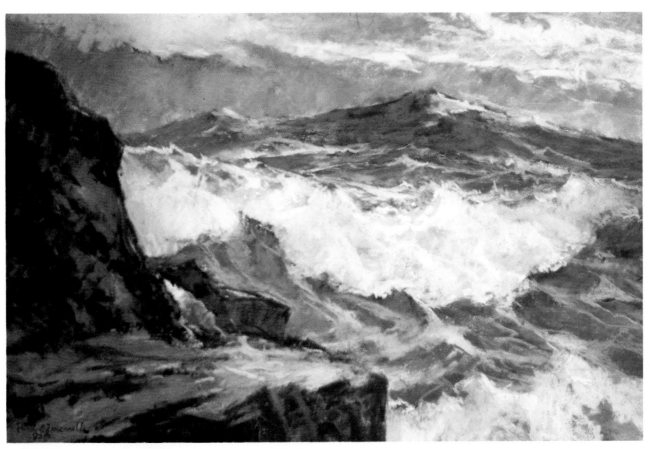

VERSION 2

In this version Zuccarelli moves closer to the rock formation and lowers his point of view. He portrays a stormy atmosphere where cool colors dominate and towering waves become the focal point. He states, "The main difficulty is in redesigning my whole composition. Past experience at sea allows me to visualize the threatening sea mood."

STORM AT PEMAQUID
12″ × 18″

MARY SHEEAN

Forces of Nature—The Beautiful Sea: Two Views

Sheean uses simple materials to create her impressionistic period piece in pastel. She spends much time doing mental planning. When she is ready to begin her sepia drawing, many of the problems have been worked out. On felt-gray Canson paper, she begins the pastel with a sepia drawing, then sequentially places layers of Nupastel, Rembrandt and Sennelier. All except the final layer are sprayed well with fixative.

With the delicate colors and Victorian costumes, and the aristocratic appearance and attitude of the figures, the pastel becomes a story. The strong rock formation sits solidly in the background, the surf unobtrusively splatters on the back of the cliff, and no one seems to get wet. It appears as if the man is waiting to get his picture taken, but the surf is lapping at his shoes. This whimsical depiction of another era is a creative interpretation of the seascape photograph and brings a smile to the viewer's face.

In her second version, Sheean uses the same seascape elements as the photograph, but she puts part of it in another time plane, with an ethereal vertical film over the center of the sea. Both seascapes are caught in a charming time warp.

STEP 1: "I do thumbnail sketches to work out the elements of the picture. I add Victorian figures to establish a theme of a Sunday afternoon on a jetty. The figures dominate and happily act as a catalyst for all the movement in the picture. I work with charcoal and soft pastel on tracing paper, and decide to try again."

STEP 2 (TOP): "The second thumbnail is again on tracing paper with charcoal and Rembrandt pastel for a color study. The figures seem to take on a life of their own. I rearrange the figures when I draw the final composition on Canson paper."

STEP 3 (ABOVE): "The rock formations are done in deep purples, brown and red with a sunny taupe for the part of the jetty. I choose a modified pink for the figure seated on the topmost rock. The dark area under her is perfect for another figure."

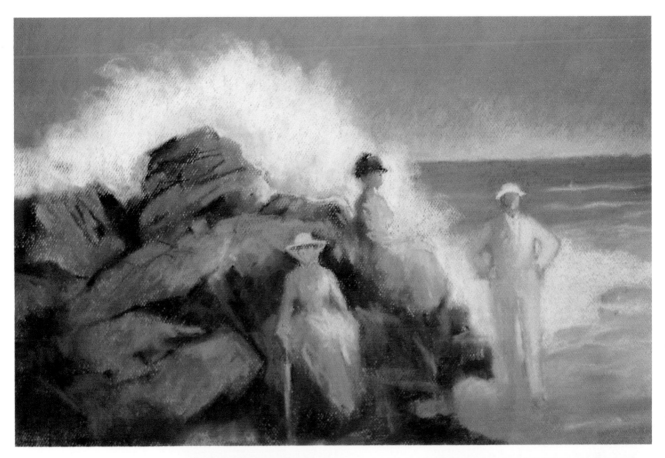

STEP 4: "The lower figure's pale green dress and straw hat are a suitable tie-in for the man's ice cream suit. For the final touches I emphasize the forces of nature. The spray from the surf frames the figures and rocks. I use a medium bluish-green by layering green, blue and grays with a violet that is a shadow color for the figures. The foreground is broken up with water patterns. At the horizon pale yellow and pink indicate sunset, giving the scene an impressionistic feeling overall."

STORM AT PEMAQUID
15½" × 26"

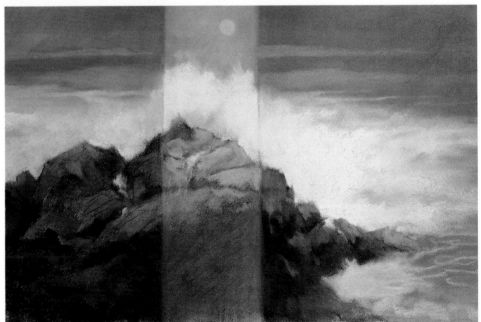

VERSION 2: "This scene is rendered in basically the same colors as the first version. The sky is broken up with streaks of sea-green against a medium blue. I've added a pane in the center of the composition, with a transparent feeling indicating a change of time."

STORM AT PEMAQUID, 15½" × 28¾"

GALLERY OF SEASCAPES

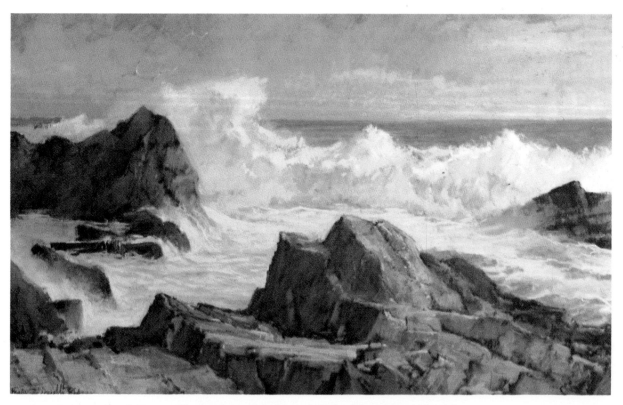

SURF AT SUNSET, Frank Zuccarelli, pastel on sanded board, 22″ × 30″. Private collection.

TIME AND TIDE, Frank Zuccarelli, pastel on sanded board, 18″ × 24″. Private collection.

Both of Zuccarelli's luminous seascapes at sunset show the clarity of the water, beauty of marine color and deftly handled joining of edges between rocks and water.

CARIBBEAN WATERS, Judy
Pelt, pastel on sanded board,
24″ × 38″. Collection of Mrs.
John P. Ryan.

The gently rippling waters of this ocean scene, although appearing quite blue, show Pelt's glowing impressionistic technique, with the insertion of a wide range of complementary and analogous colors.

FOUR
CITYSCAPES
DEVELOPING COMPOSITION

A cityscape is a recording of a particular time, place and way of life. The photograph used in this chapter accurately records the swirling sights and sounds of New York City. The overcast sky shows pollution, the streets are jammed with cars, the sidewalks with people. The colors of storefronts and signs provide fluorescent accents against the huge dun-colored buildings. The ethnic mixtures of people and clothing styles, the startling contrasts of light and dark passages, the ceaseless noise and activity, and the mottled textures of wood, brick, stone, stucco, metal and cement capture an environment that is uniquely fascinating.

USING SOURCE MATERIAL CREATIVELY
The elements the artist needs to create a powerful and moving cityscape are all part of the milieu of the city itself. The artist must pick and choose from the stimulating, colorful surroundings, and delete, simplify and arrange the part that he or she wishes to develop. There are many possible focal points in the cityscape photograph: three disparate groups of people; two streets clogged with traffic, signs, banners and traffic lights; tall buildings; and an overcast, atmospheric sky. There is visible motion everywhere, and using this source material would make it difficult to produce a static composition.

WINTER, Tim Gaydos, pastel on Canson paper, 25″ × 35″.
N.J. Veteran's Home.

STRENGTHENING THE COMPOSITION

There are many points to consider in building a good pastel painting. After deciding on a vertical or horizontal format, the imagery must be planned and blocked in. It is useful to establish the focal point or center of interest, so that lights and shadows will help build a path to entice the viewer's eye. This will then identify parts that will be made secondary or subservient to the focal point.

Massing and connecting the larger areas of dark and light will create a pleasing division of space. This makes the artist focus on the development of interesting positive shapes and negative spaces. Abstract patterns must be gracefully integrated into the cityscape.

As the pastel cityscape progresses, it must be constantly checked for correct linear and aerial perspective. The composition is strengthened by carefully developing edges—hard, moderate, soft and lost. The use of perspective, edges and color helps an artist control what part of a picture advances or recedes.

THE ARTISTS' INTERPRETATIONS

With painterly and compositional considerations such as texture, strokes and application, the four chapter artists react to the source photo with unique and personal visions. Margot Schulzke emphasizes linear and aerial perspective. Tim Gaydos turns the photograph into a glowing, eerily familiar night scene of Manhattan. Wende Caporale uses the panoramic view of the whole scene, infuses it with exciting primary colors, and captures the hustle and bustle of the street. Larry Blovits's two interpretations focus the viewer's eye, emphasize the verticality of the buildings, and with a painterly vision, crop out superfluous details.

GOTHAM CITY: THE BIG APPLE

MARGOT SCHULZKE

Capturing the Mood of the City With Perspective

Schulzke plans her pastel using a color study of the photograph. She crops the right side of the composition to form a square and chooses a split complementary color scheme of red-orange and blue-violet. Using Sabretooth paper in a gray-green tone, she places the drawing on paper, deleting unwanted objects and details and correcting the perspective of the automobile that seems to be on the sidewalk.

Immediately establishing an atmospheric mood, she plans the distribution of hard and soft edges to promote a graceful merging of the foreground and background.

Schulzke's preference for framing this piece is an off-white outer mat with a red-pink or blue liner and an off-white wood frame.

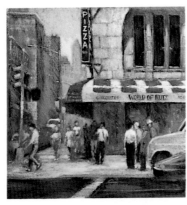

STEP 1: "I make a color study of the photograph and eliminate some details. Starting with charcoal, I follow with a pastel/turpentine wash to establish dark tones and to get an idea of a color scheme."

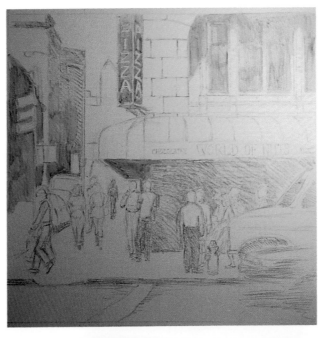

STEP 2: "Gridding the photograph to a square format, I establish perspective lines to test placement and angles. I complete the sketch and remove the grid lines."

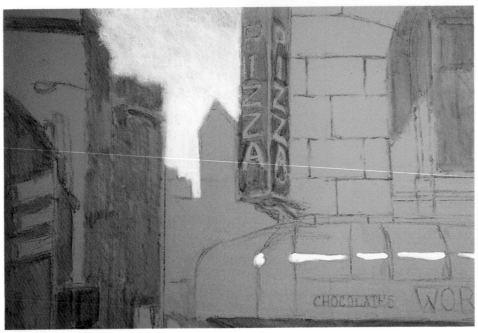

STEP 3: "Blocking in the darks, I begin with deepest blue Nupastel and wash it in with turpentine. I also add some Higgins white ink for areas that will be brightest whites. A pale blue Nupastel is washed into the sky."

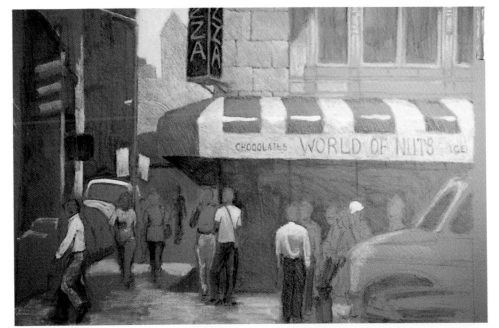

STEP 4: "I apply Nupastels in pale yellow, pale green and pale blue in the sky, washed in with turpentine and overworked with Rembrandt and Sennelier pastels of the same color. Local colors of red in the awning, dark blue on the pizza sign and pinks on the building are begun. I continue adding darks and I wash in people and buildings. The warmest shading will be on the pizza shop in the foreground."

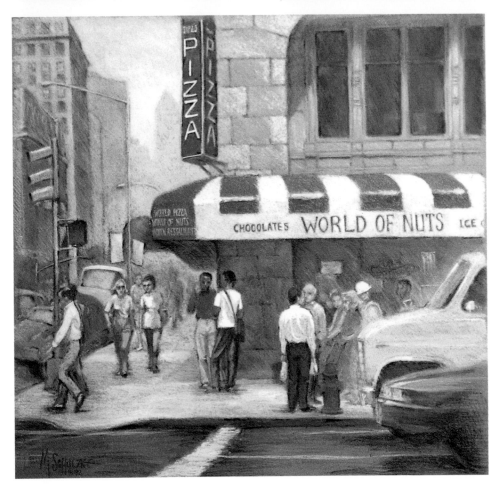

MANHATTAN: OPUS I
24″ × 24″

STEP 5: "I create distance with blues above the street and along the buildings, and continue developing the people, avoiding too much character delineation. I let the car in front fade away, and lose and find other edges to connect the background with the foreground. The gray-green of the paper is preserved for color vibration. I add more zip to color areas, and add accent darks and juicy highlights for a finish."

TIM GAYDOS

Expressing Sights and Sounds With Dramatic Contrasts

Working on black Fabriano paper, with Rembrandt, Sennelier and Grumbacher pastels, Gaydos opts to turn the black-and-white photograph of New York City into a night scene. With judicious cropping of the photo's right side, he turns the horizontal scene into a vertical. The black Fabriano paper, coupled with the reds, yellows and oranges, gives a sense of artificial light.

The inherent problem with turning day into night is the rearrangement of the elements for a strong composition. Solutions include determining the new sources of light and how to illuminate the objects with the sources in mind. Gaydos designs the light to spread out from the focal point, the corner store. He aims for maximum contrast with strong darks and strong lights.

For framing Gaydos suggests a black wood frame with a 3½″ acid-free outer black mat and a ³⁄₁₆″ inner liner.

STEP 1: "In a preliminary sketch, I develop a vertical composition to give the feeling of tall buildings that characterize the city. The black Fabriano paper makes it easy to visualize a night scene, so I concentrate on where the light strides objects and the feeling of night takes care of itself."

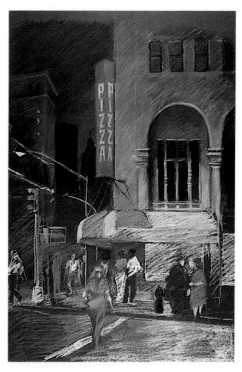

STEP 2: "I rough in the color and decide to eliminate the car on the right. Converting day to night, I determine where the light sources are, including streetlights, neon signs and light from the store window. The sky is layered with purples, black and Prussian blue."

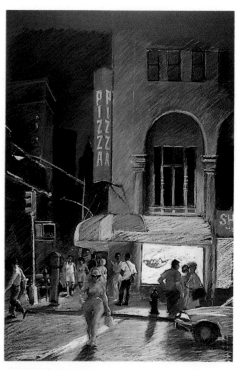

STEP 3: "I lighten the shop window, the major source of light for the lower part of the painting. Cast shadows break up the horizontal of the street. I add the red car around the corner and raise the walk signal. Figures are shifted and changed, and the car is reintroduced and shifted to the right."

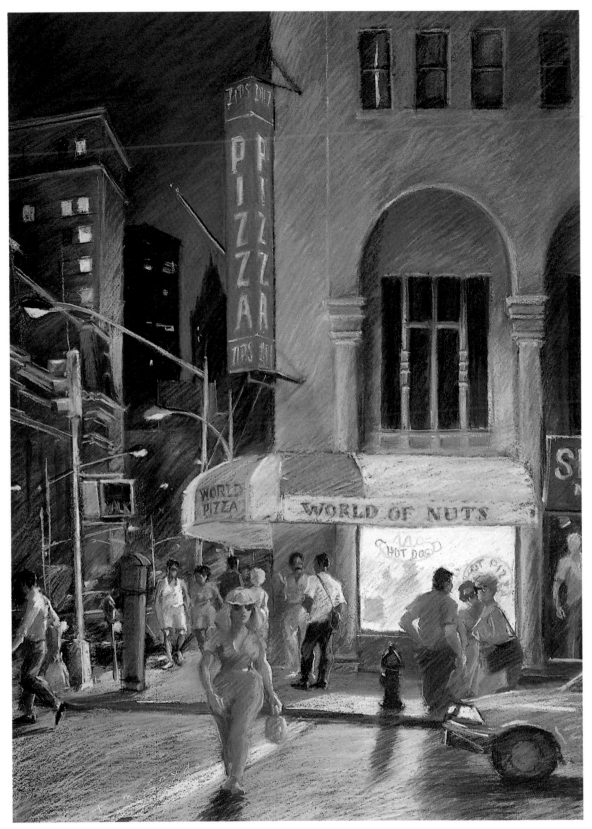

STEP 4: "I lay in headlights, streetlights, poles, windows and the lettering on the sign. I straighten out the windows, and add the mannequin in the store window at the right to move the eye to the right side of the arches. The picture is finished and the details refined, maintaining a loose feeling to create a sense of movement and urban activity."

GOTHAM CITY: THE BIG APPLE, 32″ × 24″

WENDE CAPORALE
Push the Values to Direct the Viewer's Eye

Caporale decides to keep the photograph's basic values to make her pastel realistic, with overtones of abstract qualities. She states, "My intention is to emphasize the diagonals and horizontals to bring more attention to the area of focus in the painting. To achieve this, I tend to push the values slightly to bring out the abstract shapes."

Caporale uses a vivid palette. She explains, "I have been encouraged to find color in painting from life by my husband, Daniel Greene. His use of vital and intense color made a tremendous impression on me."

Using dark gray Canson mounted board, Nupastels and Girault, Caporale creates a colorful scene of a sun-drenched summer day, so that values might be pushed and angles emphasized.

Choices for framing are a contemporary silvertone frame or a delicately carved design that would replicate the architecture of the building.

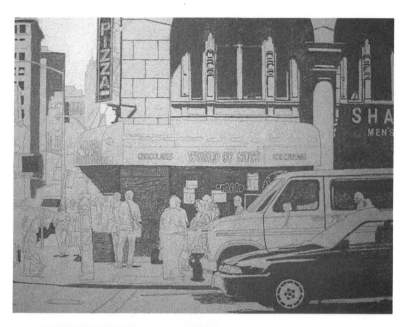

STEP 1: "I begin by projecting the image onto a Canson mounted board in cool gray. I use a sharp 4H mechanical pencil to make my drawing. Using Nupastel dark gray, I place in local color and shadows on the buildings and other areas needing darks. Nupastels are hard and do not fill in the tooth of the paper. Aerial perspective involves keeping strong values and contrasts in the foreground."

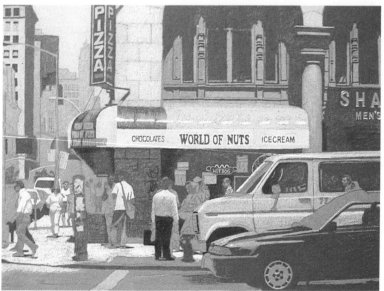

STEP 2: "There are several places where light values are accented, as early accenting helps in gauging the establishment of values. I begin to develop the center of attention with a full range of values, with a light touch to add enhancement later. This helps in the creation of other areas without allowing them to become the focus. Painting the center of attention as well as I can helps to maintain a high level of refinement."

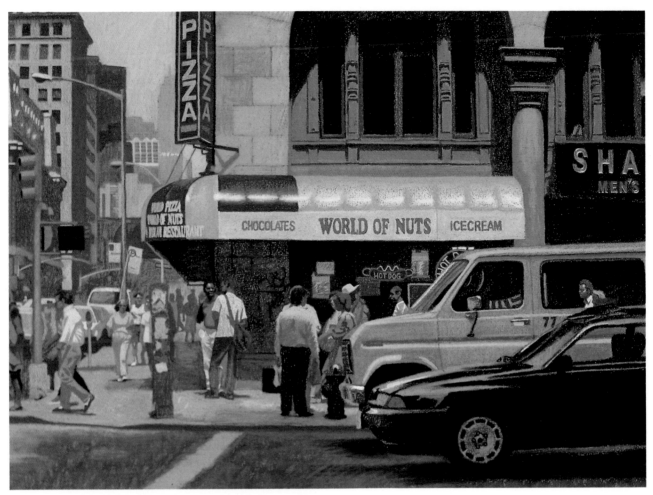

STEP 3: "I create sharp edges in the center of interest, and bring emphasis where I want by using contrasts, sharp edges and intense colors. I continue laying in values, strengthening darks and lightening lights. I choose to cover my entire working surface, just leaving hints of the paper to allow the pastel texture to be apparent."

GOTHAM CITY: THE BIG APPLE, 14" × 19¼"

LARRY BLOVITS

Eliminate Distracting Elements to Improve Composition: Two Views

Working on Canson Mi-Teintes steel gray paper, with Nupastels, Rembrandt, Conté and Prisma pencils, Blovits works to portray the energy of the city. He crops part of the cars and eliminates the figure on the left, as well as background figures and elements, to keep the eye on the focal point. He emphasizes the verticality of the buildings to describe the city. As a Midwest artist, Blovits used past experiences in New York City to select colors. He lets his visual memory help construct the color selection.

He states, "I had many problems with the rigidity of the architecture and with creating the illusion of space. This scene is not as malleable as a landscape or figure, and certainly not my favorite topic. Not wanting prejudice or narrow-mindedness to affect the challenge, I struggled with the drawing, hoping that the feeling of light would save the day."

For his second interpretation, Blovits changes to a horizontal format and eliminates distracting parts of the buildings. The tighter view allows more concentration on the elements of light and shade. Using Ersta sanded paper, 400 grit, the same pastels as version one and an oil underpainting, he concentrates on the figurative interactions.

For matting, Blovits suggests an off-white 3″ double mat. The double mat separates the drawing from the glass, an important point in painting pastels. Blovits says, "Humidity expands and contracts the paper, and touching the glass will produce a ghost image on the glass." For the frame he suggests a light gray wood frame or a simple gold frame to complement the color in the awning.

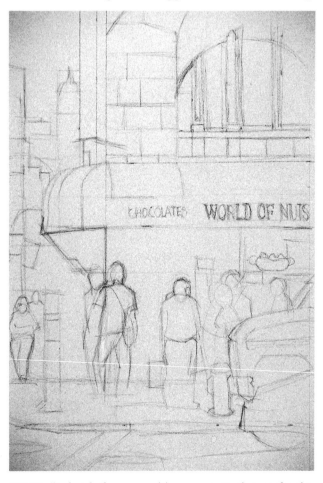

STEP 1: "I sketch the composition, concentrating on the size and location of the flat shapes. It's also very important to pay attention to perspective, especially with architecture, and the shapes of abstract positive and negative spaces."

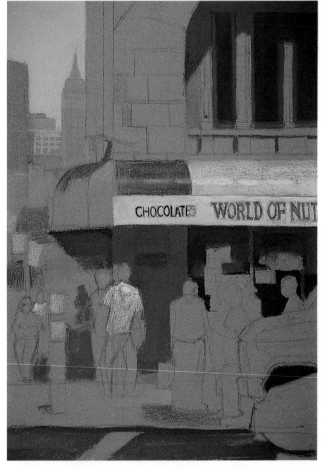

STEP 2: "I begin to lay down colors and consider the impact of those first applied to a clean surface. Color is affected by neighboring colors, and constant revision is necessary. The darks delineate the value pattern that will be sustained throughout the painting."

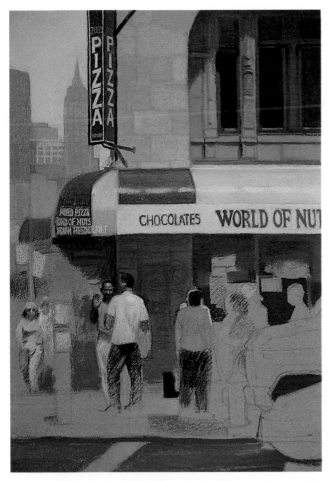

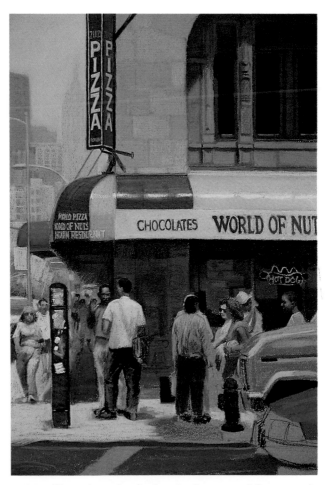

STEP 3: "The stonework facade of the building is painted with nuances of gray for upper balance. It's important to develop the composition's balance, both vertically and horizontally. I make the sign dramatic to help balance the congestion below, and some figures are eliminated for clarification."

STEP 4: "I continue developing the foreground figures and begin preliminary work on the autos. The reds of the post and fire hydrant are part of the compositional balance. The left side of the drawing needs attention to regain balance. I develop the complexity of shops and structures there."

STEP 5: "In the left side closeup you can see the development of foreground figures and suggestions used in the background. I probably revised the central figures about ten times, trying to find the right combination of structure and light."

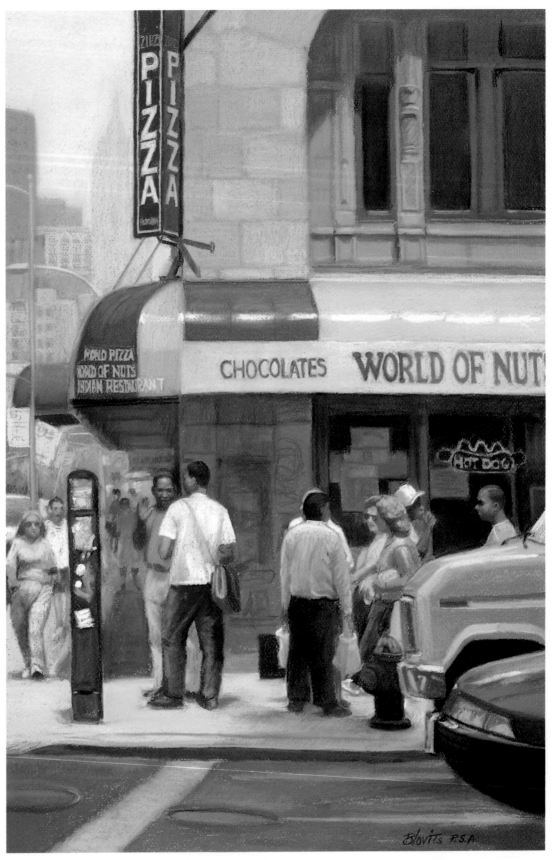

STEP 6: "I make minor adjustments all over the surface, try-
ing to satisfy my every requirement. Every time I fine-tune
one area, the adjoining one needs attention. My goal was to
make light and depth equally important factors, while retain-
ing balance and vitality."

GOTHAM CITY 1, 24" × 16"

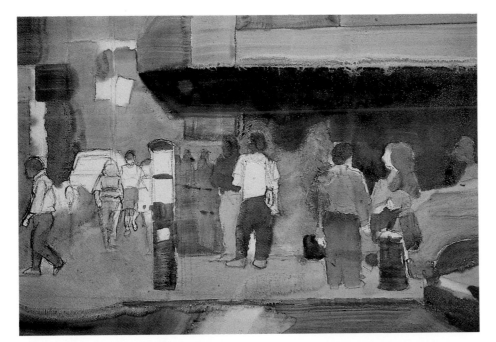

STEP 1: "For the second version of the photograph, I eliminated three-fourths of the image. The colors are determined with an oil wash underpainting, and the color buildup begins."

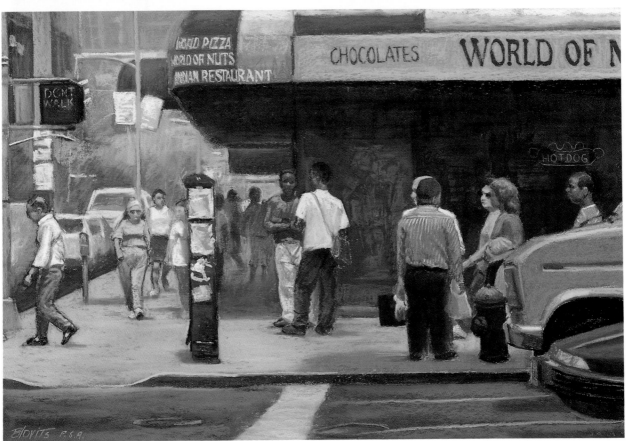

STEP 2: "I begin refining the figures in the center and right side. This area is complex, and I try to retain a fresh approach without getting bogged down in detail. I add the hot dog sign on the right to balance that area, and make slight alterations here and there. It's difficult to know when to stop, but the learning experiences from these two variations will be invaluable."

GOTHAM CITY 2
13½″ × 20″

GALLERY OF CITYSCAPES

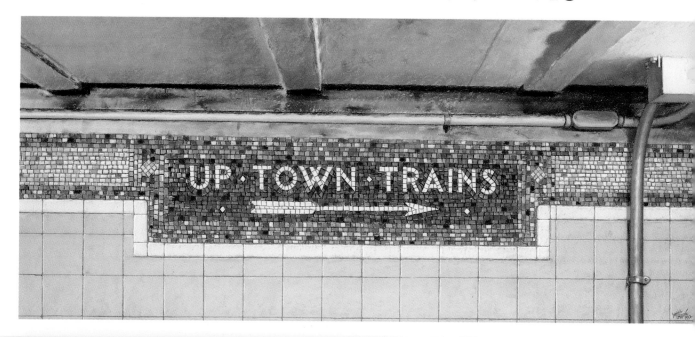

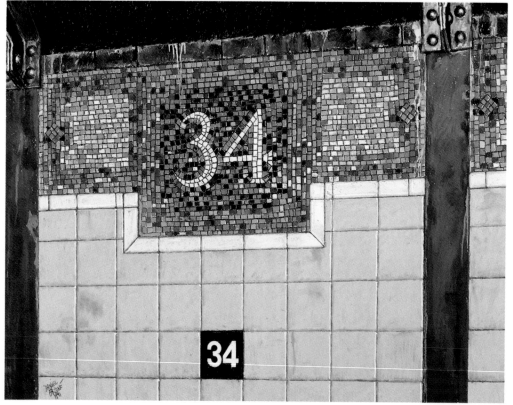

34TH STREET, Daniel E. Greene, pastel on granular board, 30″ × 40″. Courtesy of Henock Gallery.

UPTOWN TRAINS, Daniel E. Greene, Canson paper on acid-free foamboard, 25″ × 60″. Courtesy of Henock Gallery.

Uptown Trains is one of Greene's masterfully handled paintings in his New York City subway series. The colorful, glowing tiles of the subway stop, done in sapphire and royal blues, yellows and oranges, appear gem-like. The sign provides a vivid note to the otherwise dreary gray concrete and pipes. The pastel has a stark, eerie, uninhabited quality.

Greene faithfully reproduces the luminous, small tiles in the mosaic of the 34th Street subway sign. He interprets, in intimate detail, the time-worn appearance of the wall, the chips, drips, misaligned hinges and stained tiles. The bleak, deserted, grimy nature of the subway is a stark backdrop for the jeweled complementary and analogous tones of blues, oranges and yellows. It is almost allegorical—the ray of hope in the darkness.

TRIBUTE, Anita Wolff,
pastel on Adelox red sanded
paper, 36″ × 24″. Private
collection.

Wolff's colorful pastel of New York City is a textured composition with strong diagonals and verticals which lend movement to the picture. The clutter objects, the people going in different directions and the colorful flag reflected in the window, enhance the energy and vitality of New York.

SNOW SCENE

CHOOSING THE RIGHT SURFACE

The late afternoon glow of the setting sun reflects on the snow-covered backyard of a home overlooking a river. The tall, distinctive maple trees make this chapter's photograph a study in contrasts—a good subject for either a black-and-white or color study. Without some type of early morning or late afternoon light, snow can appear lifeless and gray, and reflections and shadows are not well-defined.

With little color of its own, a winter scene of snow and bare trees derives its coloration from the light in the sky, usually appearing blue, yellow, orange or pink. The time of day will also control the values of the blue or purple shadows. The large, dark maple trees with sunstruck variations in the bark become the focal point, like sentinels guarding the land.

The trees cast a wide range of shadows that create a myriad of patterns. In the absence of movement, this landscape has a hushed aura. The blanketed appearance greatly alters the existing terrain, and imparts a peaceful mood and pristine appearance. The tree shadows sweep diagonally and dramatically across the foreground.

DESIGNING A SCENE

This scene's appearance is influenced by the way the overlapping trees organize and break up space. Too many trees and awkward spaces make it necessary to prune, simplify and rearrange. Hundreds of little branches reiterated would cause a busy confusion. The little hill and dark bushes add variety and allow for establishment of swooping shadows as the hill descends. Notice the wide range of values shown—

WINTER—PRINCETON FARMS, Frank E. Zuccarelli, pastel on pumice board, 28″ × 36″. Private collection.

from the pure white of the snow to the very dark values of the trees and bushes. Assigning colors and values that approximate the values present in the original photograph requires careful scrutiny and planning. It also allows for a multitude of variations and interpretations.

SURFACES AND LUMINESCENCE

Pastel artists have a wide range of choices for working surfaces. Rough, textured surfaces make it easy to imitate the textural qualities of a snowscape. The snowy ground suggests a vigorous presentation of the masses and textures.

Aggressive, staccato strokes are easy to create on a rough surface that easily holds multiple layers of pastel. The tall trees display a counterpoint of light patterns that can reveal the rough and patterned

bark. The clarity of values in the photo gives the artists several possibilities for color and surface. To compose pastel creations on varied surfaces is to show the versatility of the medium.

THE ARTISTS' INTERPRETATIONS

The artists in this chapter paint from different perspectives and use a wide array of strokes, techniques and surfaces, including handmade pumice board and Hudson Highlands' pastel panel. Madlyn-Ann C. Woolwich accentuates the contrasting light and shadow patterns in one version. In a second version she shows the studied arrangement of pictorial elements, establishment of a new background and dissimilar light patterns. Elizabeth Mowry, using a newly developed pastel panel, simplifies the photograph to impart sparkle and vibration to the scene.

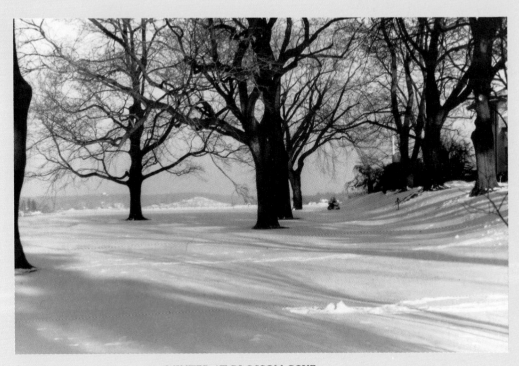

WINTER AT BLOSSOM COVE

MADLYN-ANN C. WOOLWICH

Emphasizing Textural Effects of Trees and Snow: Two Views

Working on a highly textured pumice board, with a full-value underpainting in radiant acrylic washes, Woolwich creates a randomly stroked layer with Nu-pastels. Subsequent layers of Sennelier and Rowney pastels create two vibrant versions of the winter scene. The first version, with minor positional and size changes, is a faithful rendering of the original photo. The second version radically changes the design when trees are moved and redrawn, and a discernibly populated background is added.

Woolwich will frame her two scenes with a 2″ carved gold or silver frame with a very light gray acid-free double mat, or alternately, with a wide silver frame and a 2″ linen liner.

STEP 1: "I start with a loose pencil drawing to master the shapes in the scene, and decide to simplify some of the scenic elements."

STEP 2: "Continuing on pumice board with charcoal, I work out my drawing and reinforce it with a rigger brush and blue acrylic paint."

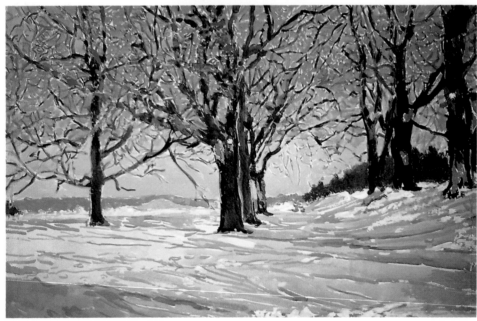

STEP 3: "With bright acrylic washes, I lay in the whole scene with a brilliant, full-value underpainting that will profoundly influence all the succeeding layers. Other artists often ask me why I bother to do such a complete underpainting when it will be covered. The answer is that I can make many changes and corrections, add or subtract elements and make many important decisions about how the painting will proceed."

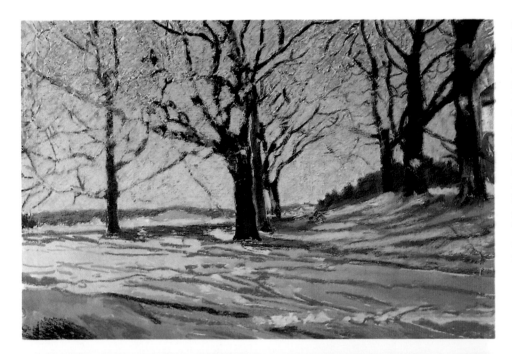

STEP 4: "Now I lay in a complete layer using Nupastels. These hard pastels are without equal when working on a hard granular surface. Matching and expanding the underpainting done in acrylic, I work carefully on the glowing sky, the luminescent light patterns, the strong blue shadows, and the dark maple trees with the light patterns glancing from the trunks and branches. The green bush patterns are done in a simplified manner."

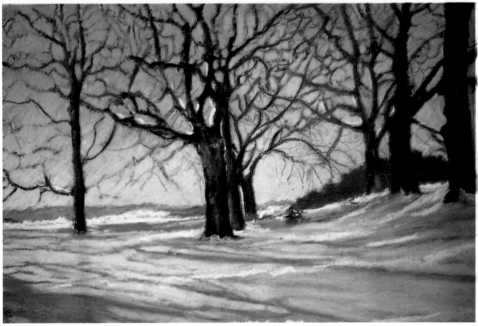

STEP 5: "I develop the light patterns and simplify the shadows. The trees are developed and darkened. Selective augmentation of the branches is accomplished, and the other values balanced."

STEP 6: "I amplify values, develop colors and add more glow to the sky by adding orange to the pink, using Sennelier pinks and oranges. The edges of the shadows are partially softened."

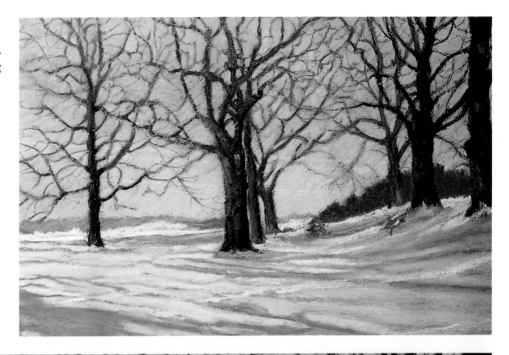

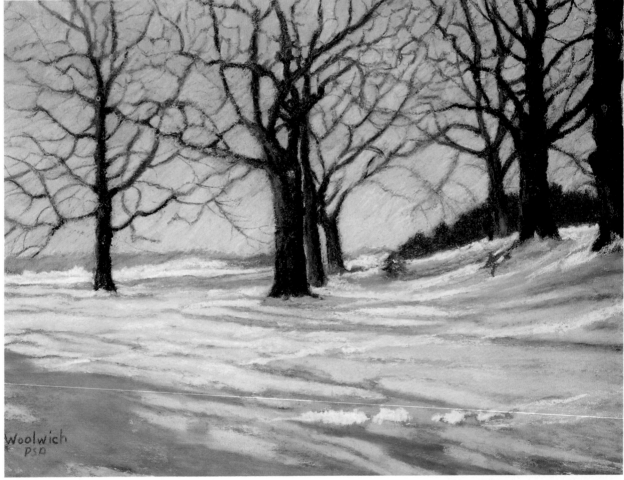

STEP 7: "I continue to develop the glow in the snowscape. The light patterns are strengthened and connected. I give some more attention to the connections of elements and reflect the pinky orange colors of the sky into the picture."

WINTER AT BLOSSOM COVE, 20″ × 24″

VERSION 2
STEP 1: "Starting with a pencil sketch to work out the pictorial elements and composition, I decide to move the trees around, accentuate the knobby quality and move the bushes."

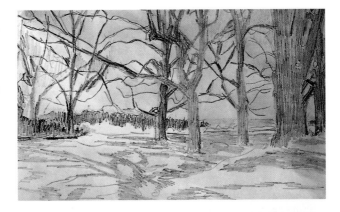

STEP 2: "After placing the drawing on the pumice board with vine charcoal, I do a complete underpainting with acrylic washes in an impressionistic manner. I decide to create a sky color of grayish blue, the colors of a bright overcast day."

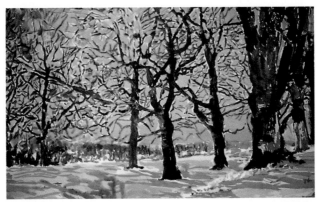

STEP 3 (BELOW): "I lay in the hard layer of Nupastels and subsequent layers of Rembrandt and Sennelier pastels to establish the patterns of lights and darks. The trees are developed with dark, rich umbers, purples and burnt siennas. I finish a strong light and shadow pattern using Sennelier purplish-blue and brown-purple, and develop the houses in the distance. I give final staccato strokes to the little piles of snow on the ground."

WINTER AT BLOSSOM COVE, 18″ × 24″

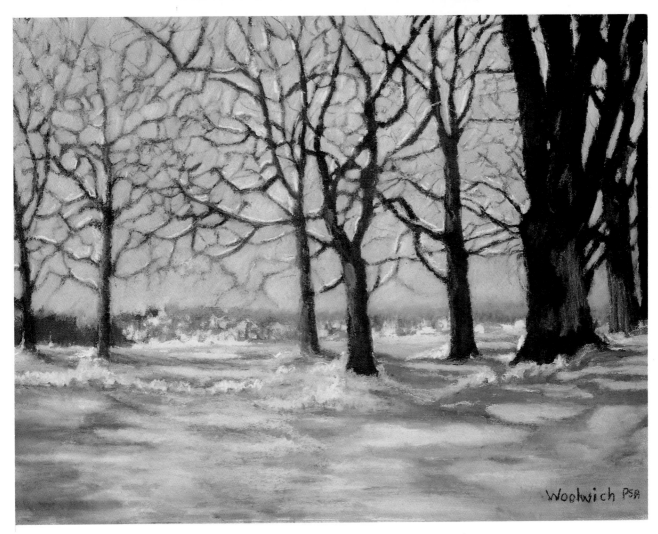

SNOW SCENE

ELIZABETH MOWRY
Selecting a Pastel Panel for a Sparkling Surface

After studying the source photograph for over a month, and using a viewfinder, Mowry selected a small part of the photo for her winter pastel. Mowry explains, "The mood and selection of color is inspired by a view of the winter sky from my studio window. Daily walks result in observation leading to ideas to include in paintings." She softens most of the tree and shadow edges in a painterly way to make an artistic, rather than photographic, rendering. Although the trees determine the shadows, the light area is carefully designed to enhance the importance of the meadow area. She works on a newly developed pastel panel made from wood and coated with abrasive pigments and acrylic resins that have a built-in sparkling quality.

Mowry chooses a dusted silver frame with a ¾" linen liner. The glass will be placed between the frame and the liner. An alternate frame would be with the same mat and glass, but with a wood and gold frame.

STEP 1: "After much thought and a feeling that I need to simplify the information, I use two L-shaped cropping angles to select a small area."

STEP 2: "Using a #91 Carb-Othello pencil, I position the main elements and do a quick minimal sketch."

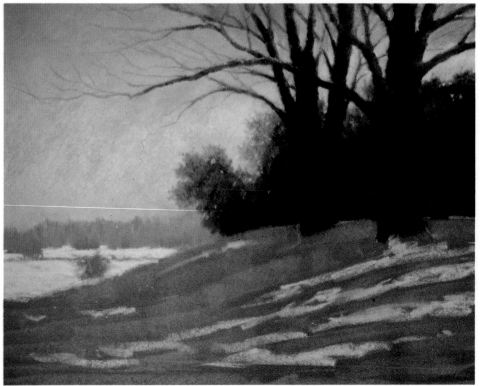

STEP 3: "Working with vibrating colors, I apply the first layer to establish large masses. The mood is set early by using soft pastels in two shades of light pink. The larger trees are defined by the first layer of umber. I use vertical strokes of rosy sienna and purple to paint in the distant tree line. I hold back detail and complete the graceful branches of the trees without reference to the photograph. The ends of the branches are lightened using warm sienna and gray purple."

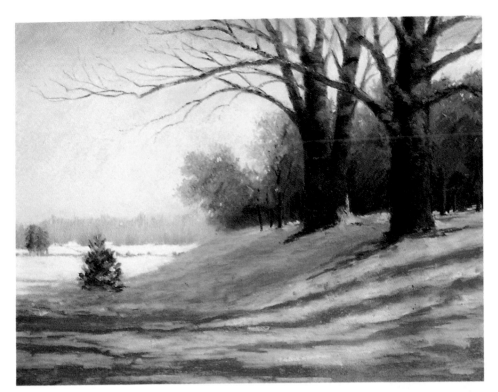

STEP 4: "To develop the foreground, I use Sennelier pastels in lush purples and teal in the shadow area, and light violet and blue-green in the sunlit places. The evergreens on the left and the smaller trees are placed in the middle ground, and I enjoy placing in short staccato strokes of broken color."

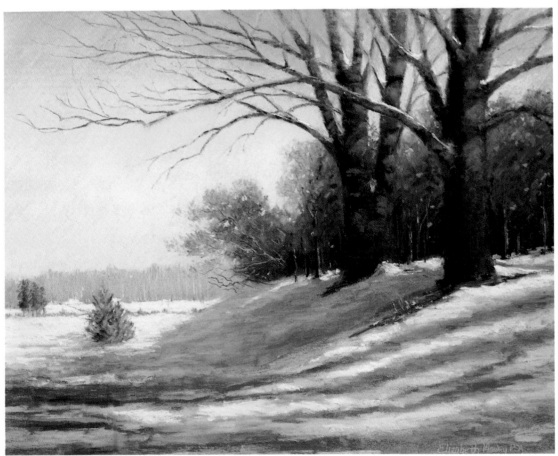

STEP 5: "I reshape the largest tree branch and add a hint of snow on a few branches, using blue-green, blue-purple and touches of pink. With a few short strokes I suggest sapling trunks and branches in the large masses, and add a few light pink Sennelier and blue-green highlights in the background."

WINTER AT BLOSSOM COVE, 16" × 20"

GALLERY OF SNOW SCENES

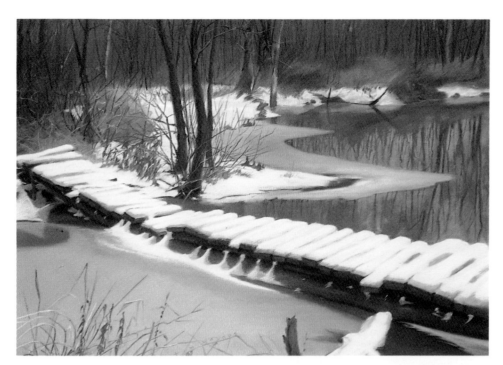

FIRST SNOW, Tim Gaydos, pastel on paper, 32″×43″. Private collection.

Gaydos's scene of fallen snow is peaceful and subdued. The few ochre and sienna accents intensify the barrenness. The strong diagonal quality of the picture is opposed by the vertical thrust of the trees, as light patterns establish a strong focal point left of center. The textured Canson paper allows for both textural surfaces in the trees and smooth rubbed surfaces in the drifting snow and water.

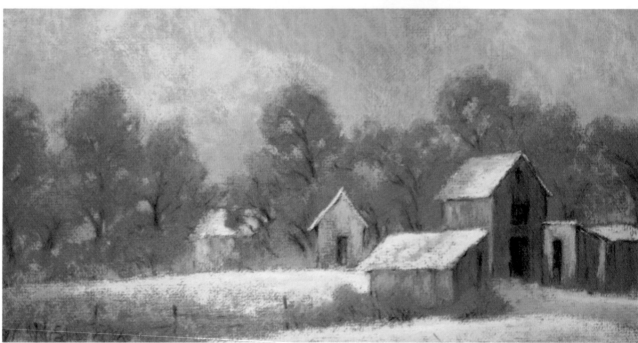

WASATCH WINTER, Margot Schulzke, pastel on pumice board, 12″×20″. Collection of the artist.

Schulzke shows the effect of a sunny day with light and shadow on snow. The granular surface heightens the texture of the snow, and the bright colors of the houses and sunlit trees combine to create a cheerful, snowy scene.

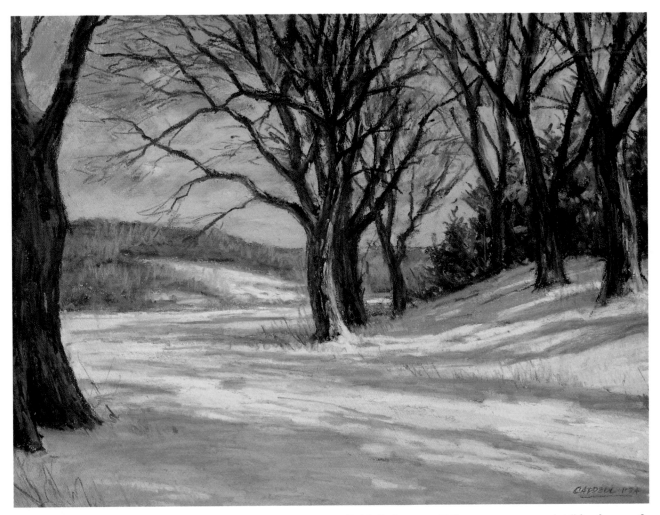

WINTER AT BLOSSOM
COVE, Foster Caddell, pastel
on Canson paper, 16″ × 20″

Caddell chose a middle gray paper to paint "the drama of light," his constant theme. He underpainted many passages with black, such as the tree trunks and evergreens, to make up for what he feels is a shortage of good darks in pastel. Most details are only suggested, allowing the viewer's mind to provide the rest.

FLOWERS & GARDENS

CREATING VIBRANT COLORS

Color is a very personal part of painting. Artists perceive what they see in different ways. Differences in color perception include intensity, lightness and darkness (including light and shadow patterns) and the degree of warmth or coolness. No matter what the source, individual perception creates individual interpretation. In this chapter, the artists demonstrate the diversity of color usage and the techniques that allow pastelists to work in many styles.

When working on flowers and gardens, the artist has nature's colors in pure form, with all the natural variations and translucencies that exist. Two versions of the same flowers will never be the same. As you look at them, something new always presents itself. The light shining through petals and distributing itself among the leaves creates shadows and transparencies that can literally make you use every shade in your pastel box.

Working from black-and-white photographs is a good way to let artists get their own sense of color to sustain and create an idea. The subtleties of color allow for great variations in approach.

Underpainting with gouache, watercolor or acrylic, or toning a surface with another paint or pastel color, sometimes diluted with turpentine, intensifies colors used in the painting. Pastelists develop colors by layering them on top of each other. Some artists use pastel lightly, and others paint and layer it heavily. Color and application are often directly connected to the subject that the artist is trying to express.

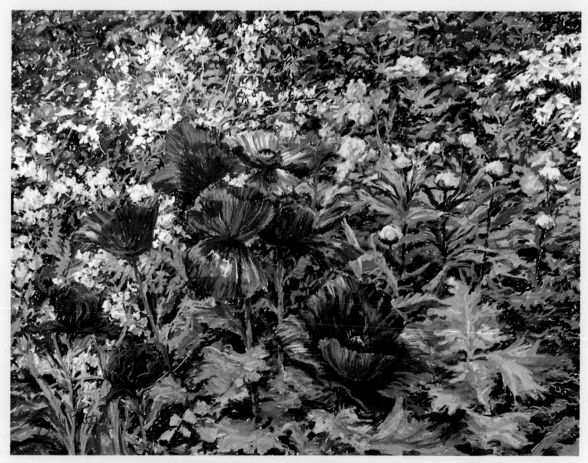

POPPIES AT GIVERNY, Judy Pelt, pastel on sanded board,
24" × 30". Private collection.

COLOR DOMINANCE

To counter uniformity and pull a composition together, a dominant color may be woven throughout the pastel. Strong color dominance is augmented by using many shades of the same color, as well as the dominant color's complement. The dominant color and complement are used near each other, or interlaced in small patches or strokes. The eye will optically mix them and the composition will have resonance in the color combinations.

COLOR TEMPERATURE AFFECTS VIBRANCY

Floral paintings can be vibrant and realistic when attention is paid to the temperature of the colors. Beautiful floral colors can be created by judiciously using a mixture of warm and cool complements.

In the lily composition by the artists in this chapter, the values are clearly stated in the photo, but the color choice is individual. The main problem for the artists was designing the background and incorporating color that would complement and beautify the flowers without overpowering them.

Analyzing and interpreting the shadowy background of the picture, the artists employed analogous and complementary colors that in some way alluded to vague forms of lilies, leaves, stems or some broken color forms.

THE ARTISTS' INTERPRETATIONS

Each artist in this chapter is primarily concerned with color. All pastel paintings, however, deal with the usual problems of composition, values, edges, etc. Each painting shows a decidedly individual quality, coloration and technique, and there are cool, warm and limited color uses in the compositions. Anita Wolff shows that one artist can derive two very different pastels from the same source material. She achieves control and unity by using complementary colors. Judy Pelt uses transparent, translucent and opaque qualities to evoke the vibrant potential of flowers and pastel. Elizabeth Mowry describes how to make an exciting composition with her own limited palette, using complementary colors.

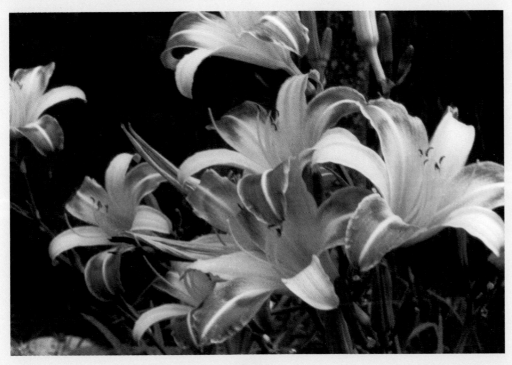

LILIES

ANITA WOLFF

Establish Unity With Color: Two Views

Wolff is a California artist who paints impressionistically. She avoids overworking a piece, and prefers to let the viewer's eye and mind do some of the mixing and interpretation.

She begins with a gestural drawing on precut white drawing paper. This evolves into a value drawing to study spaces and shapes, and to design the lilies, buds, stems and leaves. For her finished pastel, Wolff transfers the drawing onto Ersta sanded paper and works with both hard and soft pastels in order to create a glowing image.

In her second version, Wolff utilizes the blue-green of aqua Canson paper to establish a basis that pulls the composition together. The color scheme is blue, blue-green and violet with complementary oranges and yellow-oranges. She states, "I wanted this painting of the lilies to appear as if we are viewing it in evening light—a romantic and reflective mood. I select an analogous color scheme in advance and maintain it throughout."

STEP 1: Wolff works out the rhythm patterns of the flowers with a series of gesture drawings.

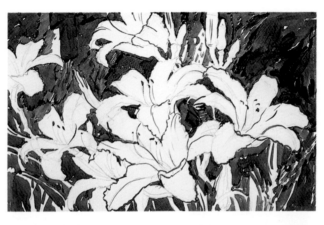

STEP 2: The value plan of basic light and dark patterns is worked out with a watercolor brush and black ink on white drawing paper.

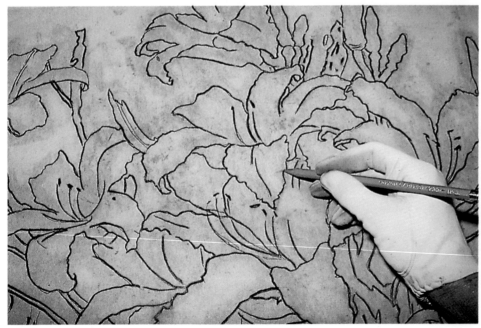

STEP 3: "I establish an underpainting on the Ersta sanded paper with pink, blue and purple pastels and turpentine. I trace the lines of the drawing from the black-and-white value drawing, turn the pattern over and cover the back with red Conté crayon. Taping the pattern to the sanded paper, I redraw the lines in hard pencil to transfer them."

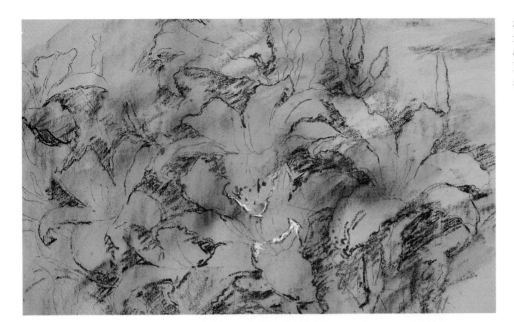

STEP 4: "I add darks to the foliage to strengthen the composition, and place brilliant reds and red-violets in special positions."

STEP 5: "I show changes by drawing in white, as I increase the size of the lilies to give them importance in the composition."

STEP 6: "Still using white, I give veins and petals movement and direction. I gray the centers with a red-green combination, place darks under the petals and add stamens."

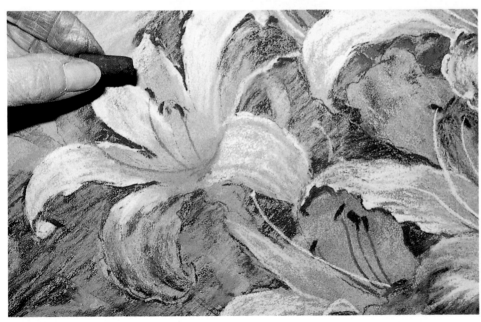

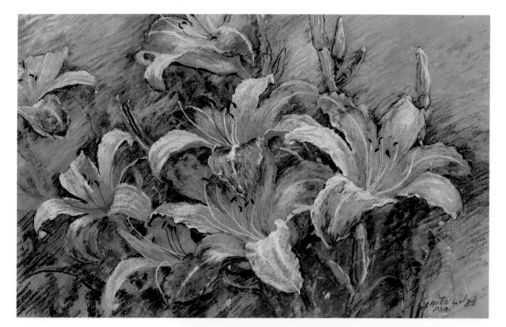

STEP 7: "I place in the finishing strokes of violets, creams, pinks and pale blues to heighten the complementary colors. I incorporate the background in an open, impressionistic technique, and carefully weave the lilies and the background together."

LILIES, 14¾" × 21¾"

VERSION 2
"In this version, I try to establish a romantic and reflective evening mood. Working on aqua blue Canson paper with a blue ink underpainting, I use blue, blue-green and violet and their orange and yellow complements."

EVENING LILIES
14¾" × 21¾"

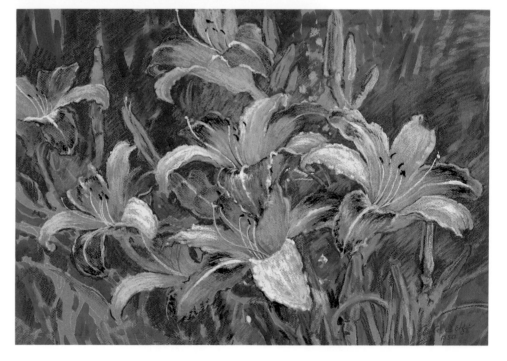

ELIZABETH MOWRY
Selecting a Limited Color Scheme

Mowry can frequently be found sitting in her large backyard garden, drawing flowers and garden scenes. Her work shows the delicacy and sureness of one who is familiar with floral subjects. In this sequence of lilies, she sets out to do a representational pastel.

Working on mounted Ersta sanded paper, she decides to keep the background simple and suggestive of sky and water. For her limited color scheme, she selects from the following color groups: orange (burnt sienna in light, medium and dark), blue (blues, blue-purples in light, medium and dark) and green (deep to olive with blue-green as a tie-in color to the green and blue groups). Mowry explains, "My intent is to get a delicate peachy look without making it look chalky."

Working with small, square pieces of Nupastel, she uses an abundance of hard edges with straight-edged stems and leaves to distribute and unify the color. "I will frame this work with a cream-colored, linen-covered deep mat and a very simple gold-leafed wood frame. It might also be done in the cream linen mat and a dark cherry wood frame."

STEP 1: "I make a thumbnail sketch and work on developing the composition horizontally with a diagonal division of light and dark values in the background."

STEP 2: "I tape off the horizontal format space to 15″ × 27″, leaving space above and below in case adjustments are needed later."

STEP 3: "I choose Nupastel 305 and use a side stroke to cover the area that will be dark. With a foam poly-brush I apply Minwax ebony stain to the lower diagonal of the sketch, and pull the ebony tone into the upper part of the picture. Next I begin the crucial step of laying in an apricot lily that will vibrate against the background. I continue adding basic tones to all parts of the flowers."

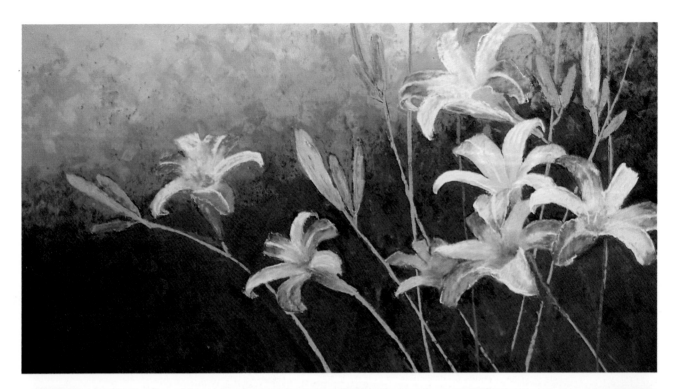

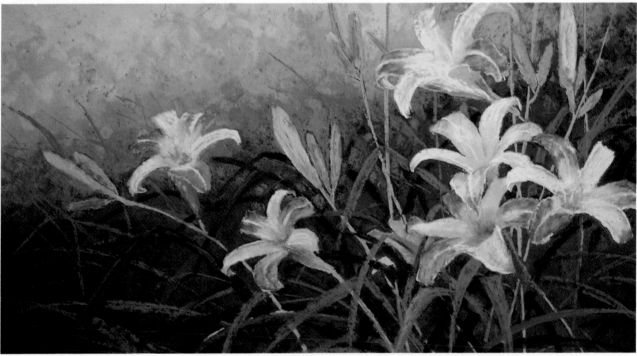

STEP 4 (TOP): "I carefully adhere to correct petal structure for the daylilies. No matter what the interpretation, the buds and other compositional elements have to be accurate. After considering a garden scene background, I decide to suggest only sky light. With lightest blues and purples at the top, and the deepest purples where light meets dark in the under-painting, I link the areas and interweave greens into the blues and purples, and work on leaves and stems."

STEP 5 (ABOVE): "I pencil in a few leaves with a gray Carb-Othello pencil, but quickly abandon that technique and just continue spontaneously to get a leaf and stem pattern going. I step back and take another look at the sky area."

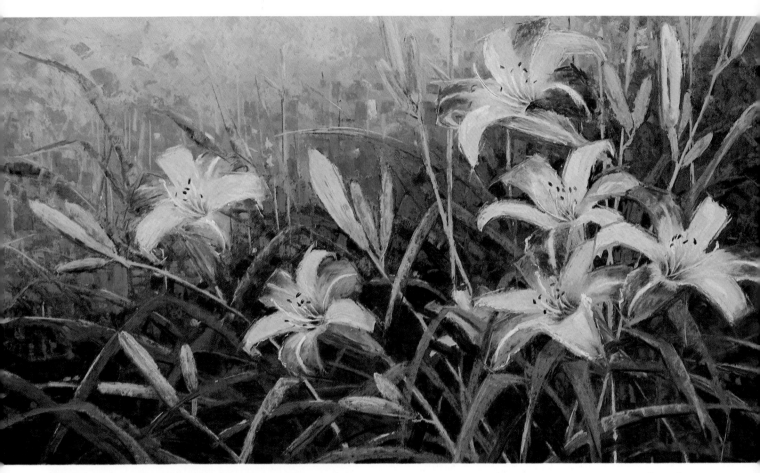

STEP 6: "I use a piece of Nupastel 305 on its side and insert deep color between some of the leaves on the bottom of the painting. I broaden petals and work on form and color in all the lilies. In the center of each lily I place a deep value of sienna. I highlight leaves and unify colors, and complete the background with precise side strokes of purple and blue. I add hints of other flowers, buds and leaves so that the viewer will see this as a mass of lilies."

LILIES, 15" × 26"

JUDY PELT
Using Complementary Colors to Make Flowers Glow

Working in a studio with a thirty-foot window wall and a north light exposure, Pelt has superb light all day. "My main problem is that I never work with black-and-white photographs," she said. "Even in a terrible color photo, you have a hint of color. I am basically a very spontaneous person, and rely on my emotional response for a stimulus."

She works on Ersta sanded paper in rough grit to lay in an underpainting with pastel and turpentine. To create a realistic painting where the background recedes, she chooses violets and an analogous (adjoining colors on the color wheel) color scheme for the flowers. The yellows and violets are complementary colors, as are the oranges and blues. Using complementary colors imparts a vibrant and glowing appearance.

The patterns of light and shadow are very important. Even with the darkly painted background, there is a wide range of values in this painting. The sunlight striking the petals develops the patterns of light. Pelt states, "This is a bold painting in a high color key—a very strong statement.

"For framing, my suggestion is a wide linen liner with a simple gold cap frame or a 3½" double white mat and a white contemporary frame to enhance the bold quality of the painting."

STEP 1: "I use vine charcoal to sketch in negative spaces and flower shapes. With red and blue-violets, I block in the negative spaces. This sets up a cool background to interact with the warm flower colors. Using a turpentine wash, I then brush over the red and blue-purples already applied."

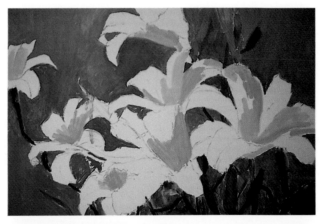

STEP 2: "I soften the darks and develop the petals. Using cadmium orange, deep cadmium yellow and deep pinks adds transparency to the petals."

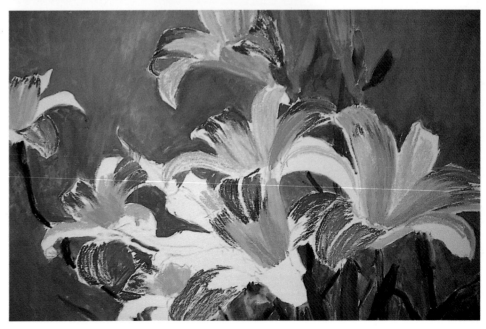

STEP 3: "To give interest to the petals, I scumble in warm colors to add vibrancy to the cool background. This adds air to it, but retains the opaqueness."

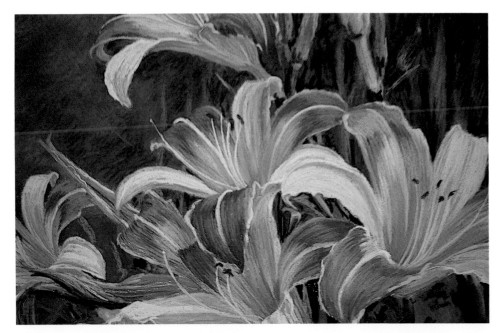

STEP 4: "I finish the blooms and develop the central lilies. Many different colors and values within the color scheme chosen are placed into the flowers."

STEP 5: "I add cobalt violet and ultramarine blues in the upper right. I work loosely and energetically to give the hard angular feeling that stems of lilies have. The strong colors of the flowers dictate the intense hues in the foliage. The softer upper left of the painting gives the eye a place to rest."

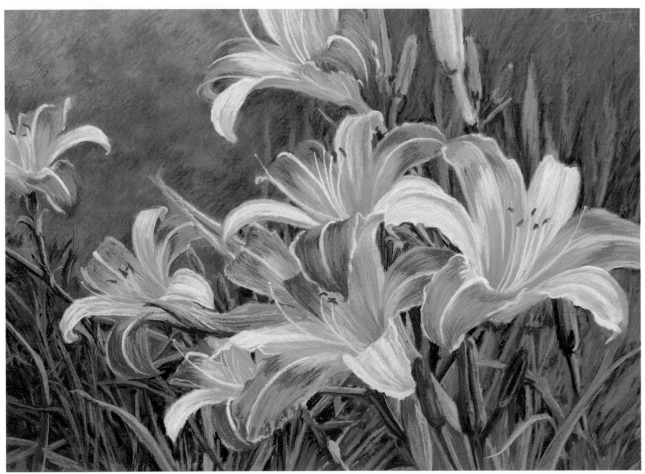

LILIES, 18″ × 25½″

GALLERY OF FLOWERS

SPIRIT OF APRIL, Anita
Wolff, pastel on paper,
30″ × 32″. Private collection.

Wolff shows her ability to
combine flowers and other
objects of varying colors into
a beautiful still life. In this
example, color spotting and
complementary purples and
yellows can be seen.

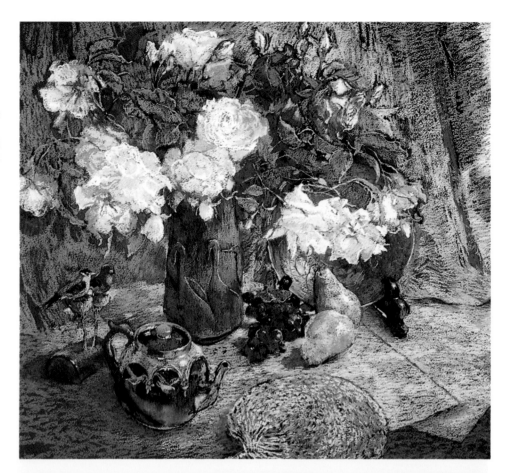

UNTENDED GARDEN,
SPRINGTIME, Elizabeth
Mowry, pastel on paper,
27″ × 56″. Private collection.

This is another glowing example of a floral by the "pastel
poetess of the Hudson Valley." The vibration of the pinks,
blues and greens adds shimmer and excitement to the pastel.

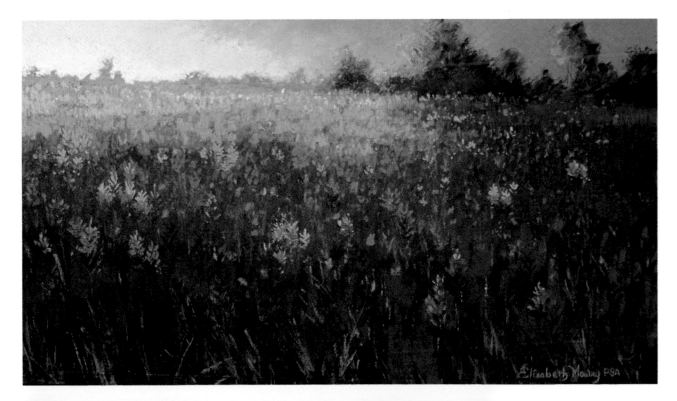

FOUR O'CLOCK HILL
Elizabeth Mowry, 27″ × 36″,
pastel on paper. Private
collection.

The glowing dark of the hill
is punctuated by the irides-
cence of the four o'clock
flowers. This dramatic flo-
ral landscape is enhanced by
the intrinsic glow of the me-
dium.

FLOWERS OF THE FIELD
Judy Pelt, pastel on paper,
22″ × 28″. Private collection.

Complementary colors and intuitive composition make this
field of flowers spontaneous and beautiful. Pelt's subtle com-
bination of abstract patterns and impressionistic subject mat-
ter shows skillful handling.

THE PORTRAIT

MANIPULATING LOST AND FOUND EDGES

Every pastel artist approaches portraiture in a very individual way. These differences can be seen in how a pastel is built up in texture, color or tone, and in the handling of negative spaces, lights and shadows, and edges.

In portraits, colors advance and recede, causing planes of the face to advance and recede. Solid planning of negative spaces, color balance, graceful placement of the subject, and deciding the focal point of the face are crucial to the process.

CREATE THE ILLUSION OF DEPTH

Principles of edges and application are at work when the model is the important part of a well-balanced composition. Lost and found edges, or sharp and fuzzy edges, or those formed when two unrelated tones are melded together, give depth and dimension to a pastel portrait. The periphery, or outside edge of the model, must be joined with the background in a gradual and attractive way. This can be done by feathering edges or by bringing some of the background color into the model and some of the model's color into the background. The artist will strengthen some edges, while some will be less firm. Others will flow into one another in a soft manner, or will be lost altogether. This helps establish the figure in space and promotes a three-dimensional effect.

SOUTHSIDE IV, Claire Miller Hopkins, pastel on sanded paper, 22″ × 27″. Collection of the artist.

Crisply defined, hard edges are usually seen away from the light, often in shadow and applied thinly. Thicker, softer edges facing the light create a rhythmical flow of movement and induce the viewer's eye to move through the painting. Good edge control defines the difference between a finished painting and one that appears unfinished. There are many degrees of hard, firm, soft and diffused edges. Learning to weave dissimilar color and values together with control is essential.

THE ARTISTS' INTERPRETATIONS

The four artists in this chapter have a highly personal approach to the subject matter, gleaned from long years of experience. Foster Caddell achieves beautiful flesh tones as he weaves his "atmospheric effects" to create a portrait of great depth. Claire Miller Hopkins contrasts sharp and soft edges, using limited color and value for her beautifully designed portrait of a cowboy in an outdoor setting. Bob Graham, with attention to the problems of light and shadow, and focusing on obtaining a strong resemblance, creates a powerfully personable portrait head. Mary Sheean, with many years of commercial art in her background, is unable to contain her enthusiasm. She incorporates her model into four different outdoor scenes for her environmental portraits. All of the artists lend life, character and vivacity to their work through the elegant usage of hard and soft pastels.

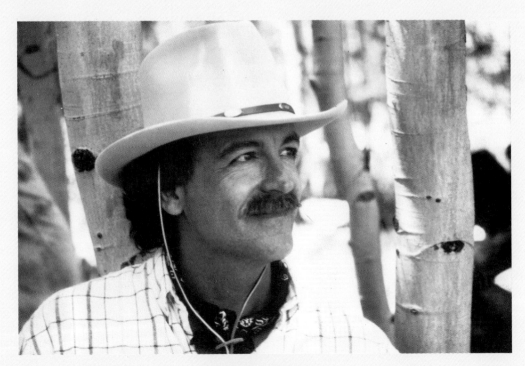

COLORADO COWBOY

FOSTER CADDELL
Using Luscious Color for Lost and Found Edges

Caddell, a Connecticut artist, teacher and author, customarily works from a live model. Working from a black-and-white photograph is a radical departure for him.

By simply using charcoal, Canson paper and soft pastels, he gives much attention to soft edges and the simulation of bioptical vision, or the way we *really* see. He tries to avoid hard lines and edges, and paints his three-dimensional portraits and figures with soft edges, giving the illusion of space and air around them. Diligent attention to color, light, values and careful modeling breathes life and personality into the subject. Caddell's characteristic strokes of luminous color are readily discernible, and the strong and humorous character of the model adds a personal note to the portrait.

The lack of a sufficient range of darks can be overcome by underpainting a passage with a black base. To focus interest on the person, he uses wide frames of gold or wood with a linen liner.

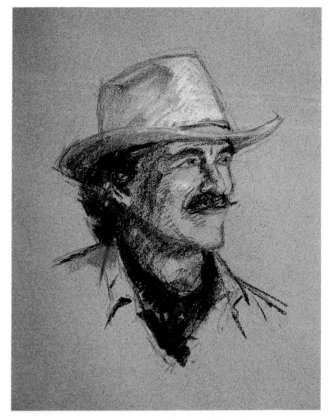

STEP 1: "On a sheet of Canson Mi-Teintes #432 gray paper, I lightly sketch the subject. With attention to value, I begin modeling the face as a sculptor would."

STEP 2 (TOP): "I suggest the value range of lights and darks to create form. There is such a paucity of dark values in pastels, I frequently underlay passages with black."

STEP 3 (RIGHT): "I overplay the values a bit to avoid the timid decisions that students frequently make. Note the introduction of red in the bandanna that reflects up into the lower side of the jaw."

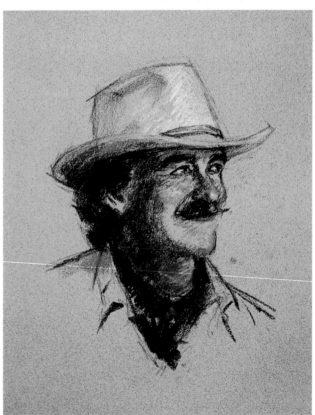

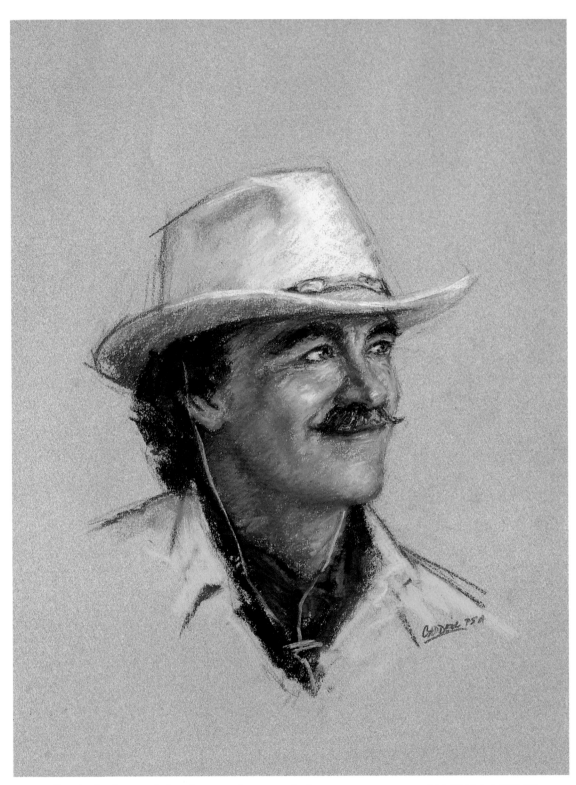

STEP 4: "In the final stage I bring the portrait to a conclusion without any hard or definitive lines or edges. The paper itself supplies much of the hat color and value. In a portrait like this I always have the clothes play a subordinate part in the overall orchestration in order to focus on the character of the person. Some construction lines are left even in the finished work. This adds to the artistic conception of 'letting the viewer see how you get there.' "

COLORADO COWBOY
20" × 16"

CLAIRE MILLER HOPKINS

Controlling Edges to Promote Tonal Design

Sketching with charcoal on German snuffing paper (beige Ersta sanded paper) bonded to acid-free board, Hopkins continues with oil and turpentine washes, and layers of hard and soft pastels. She creates a strong environmental portrait that captures the personality and character of the model. She explains, "I feel that using earth colors will help convey the outdoors and the model's intense connection to his environment."

Hopkins feathers edges and pulls the edges of adjoining values together by adjusting dissimilar values. This intentional tonal design keeps the eye moving through the painting. She plans her light and dark patterns to help set the mood, time of day and general atmosphere of the setting. The key of the palette reflects and portrays a particular mood. The play of light and shadow gives the subject importance and pushes other elements into the background.

Hopkins suggests framing this and other similar large pastels without a mat, using a gold insert and cloth liner. When using a mat, it will be a 4″ or 5″ double mat. It is also helpful to put a third mat, cut with a larger opening, behind the decorator mat to allow pastel dust to fall behind the double mat.

STEP 1: "I tone my sanded paper, bonded to an acid-free board, with washes of burnt sienna and raw umber. Loose brush textures create an uneven surface. My first placement in charcoal is adjusted until the placement of the head is pleasing. Background shapes and basic patterns of light are begun."

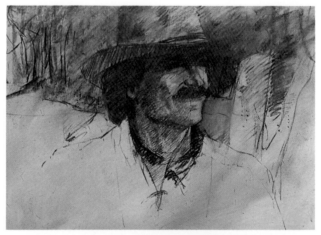

STEP 2: "I continue drawing with vine charcoal, seeking a harmonious, somewhat abstract background. I search for a focal point to keep the emphasis on the upper part of the picture. I try to keep the figure moving in and out of the background and to involve the viewer in the same movements."

STEP 3: "I introduce a dark reddish-brown into the darker values of the charcoal drawing. This is my underpainting. With a Nupastel in a middle-value tone, I attack the light area. I often use Nupastels until the midpoint of the painting because there is a low dust buildup. I will then switch to soft pastels."

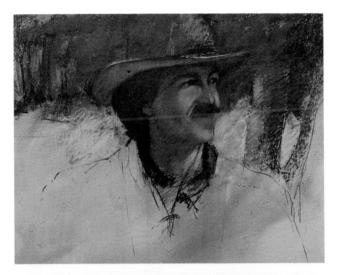

STEP 4: "To integrate the figure with the background in a painterly way, I concentrate on designing the space behind the man, adding olive greens and medium reds. I redefine the drawing with charcoal, and begin to vary edges, softening some to meld them with the background."

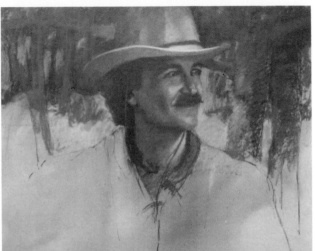

STEP 5: "Medium and dark ochres are added to the color scheme, and I move the hat back into the surrounding space with soft edges on the left. The hard-edged brim will bring the front of the hat into the foreground with the lightstruck face. This provides the strong focal point."

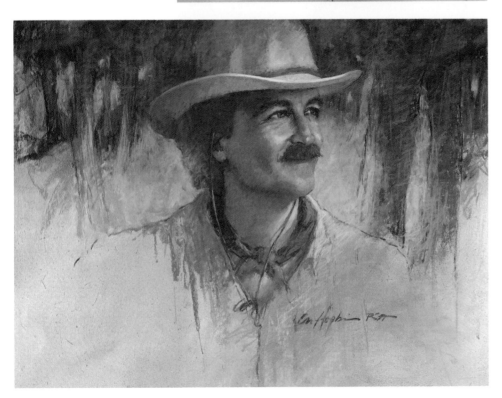

STEP 6: "While carefully building up the values and colors of the face, I keep the values of the hat low and knit it into the background. The bright front brim brings the viewer's eye to the face. The background is treated loosely, yet I try to convey a feeling of trees and late sun. I enliven the pastel with touches of red, and continue with loose multidirectional strokes in the grass and trees."

COLORADO COWBOY
22″ × 27″

MARY SHEEAN

Define Edges With Negative Space and Strong Light: Four Views

Feeling that they are the most important part of the composition, Sheean creates carefully planned negative spaces. She plans her pastels on tracing paper and moves all the elements around, designing the negative spaces and working until she attains a pleasing composition. Working with simple pastel and paper materials, she uses triangular shapes to plan a solid composition.

"To smoothly join edges of different values, the tones should flow into one another," Sheean emphasizes. "To do this I extend the value beyond the area where I want that particular value to be and pull the tones of the adjoining area over it. Sometimes the value may need rubbing and adjusting for a smooth and painterly transition. It is necessary to have enough pastel on the paper to be able to do this."

With 17th and 18th century portraitists as models, Sheean portrays what the person in the picture is like. Her interpretation of this subject sees the cowboy not as a dreamer, but as a person with something to do. She tries to personalize a portrait, describing the subject and what he does. In an imaginative approach, Sheean develops four possible portraits from the same photographic source.

Sheean frames her pastels with wide off-white double mats and thin metal or wood frames. The elegant ones are framed as oil paintings, with a wide gold frame and a linen liner.

"Thumbnails are one of my best tools to determine composition, values and relationships. I work on tracing paper with charcoal pencil, and do a series of different views."

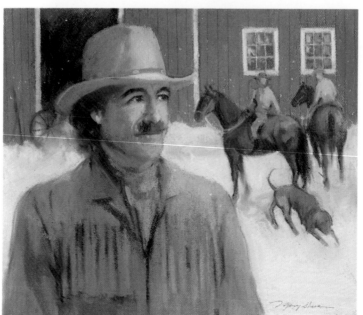

VERSION 1
"The scene is snowy, and I choose colors to intensify the outdoor feelings, and dress the cowboy in buckskin. Hard, firm and soft edges are played against one another in the planes of the face. The blue scarf shows adjoining soft and firm edges."

COLORADO COWBOY I
16" × 26½"

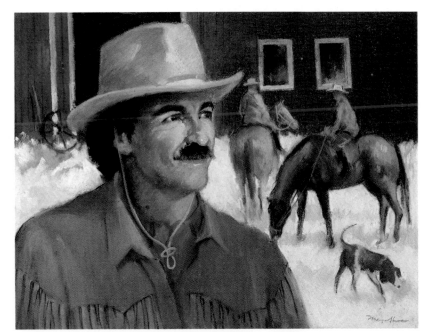

VERSION 2

"Upon reexamination, I felt that I had missed the mark. I completely redid version one with the following changes: corrected static space and made the cowboy larger, worked to make the subject more lifelike, and rearranged the size and placement of the horses and dog. The red barn retained the same importance, but I broke the snow irregularly across the picture plane. If you compare the first rendering to the altered one, you can see that it pays to take a second look."

COLORADO COWBOY II
16" × 26½"

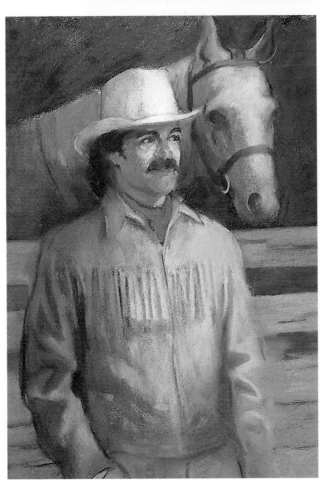

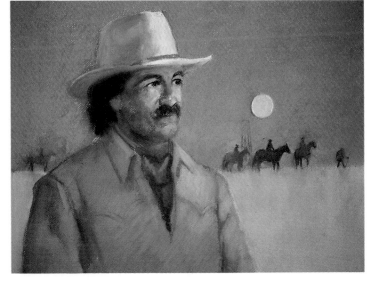

VERSION 3 (LEFT)

"From the many thumbnails I sketched of the cowboy, I feel this one is worthy of further development. The horse's head coming over the shoulder makes a dramatic picture. I crop the background and enlarge the figure, and darken the spaces around the heads to push the whole area slightly out of focus. I flood the right side of the jacket in a brighter value, which enhances the pale blues in the hat."

COLORADO COWBOY III
26½" × 16"

VERSION 4 (ABOVE)

"Putting the cowboy to the left of the picture, I join the sky and the ground together at the horizon. I use strong values for the shadows on the cowboy and warm values on the lighted side of his face. I am pleased with the simplicity and drama of the piece."

COLORADO COWBOY IV
16" × 26½"

BOB GRAHAM
Using Edges to Promote Resemblance and Character

With Sennelier dark brown sanded paper, charcoal, Nupastel, and soft pastels and fixative, this Louisiana artist lays in a gestural drawing for size and placement. The shadow areas of the features are added, and light patterns are balanced in color, chroma and value. Building on the abstract qualities of line, texture, shape, shade and color, Graham works in impressionistic color. This lets him make changes rapidly and thoroughly to achieve the balance that he considers the most important aspect of portraiture. The next step is to add a midtone or halftone between the shadow and light sides, and make gradual soft changes in edges, followed by pigment changes for lips and cheeks.

Explaining this feeling for edges, Graham says, "I believe that shadows should be mysterious. Light planes carry the ideas of wakefulness and work. When I lose an edge, I try to have a feeling of warmth or heat. In the shadows I want to feel that I am free from the obligations of seeing edges or barriers. Lost edges between color areas allow stimulation and imagination. I achieve a painterly effect with lost edges by repeating a color in each mass that I am joining."

Graham frames his portraits without a mat, and puts them in a classic frame with a linen liner.

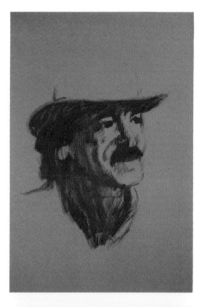
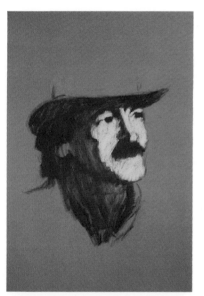

STEP 1: "I analyze the dark and light shapes of the subject, looking for broad areas to lay in color. I use a dark blue-violet pastel, slightly hard, to block in the shadows accurately."

STEP 2: "Next the light plane is laid in with yellow. This plane includes the eyeballs, teeth, lips and halftone or middle tone. I mix colors on paper with several applications."

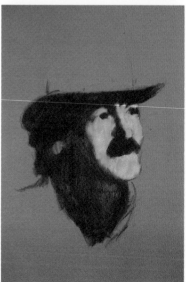
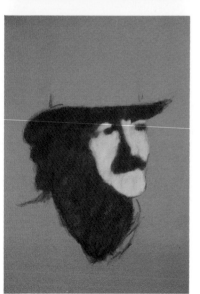

STEP 3: "I develop the light plane with pink while continuing other color additions. A deep red in the shadows brings the balance closer to my inner vision."

STEP 4: "Adding light and dark turquoise turns out to be an intermediate step, requiring the addition of violet to make this color manageable."

STEP 5: "A bright orange adjusts the color of the light plane and along with the turquoise and violets, I achieve a better balance of lights and darks."

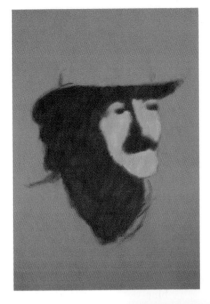

STEP 6: "I lay in the halftone to give roundness or dimensionality to the face. I apply rich color to the face to produce a blended effect: pink for cheeks and nose, violet around the eyes, green around the mouth area and a little rust color on the chin."

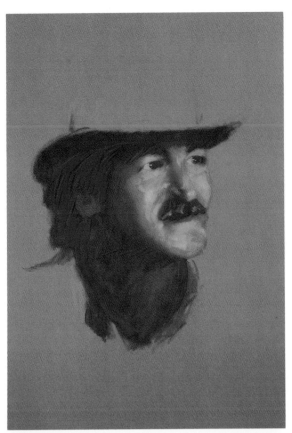

STEP 7: "With great attention to edges, I work yellows and violets into the face and redefine features. I lose the edges at the right of the picture with yellow ochre, and repeat the color in the hat and neck for continuity. This achieves lost and found edges and gives a painterly effect."

COLORADO COWBOY
24" × 18"

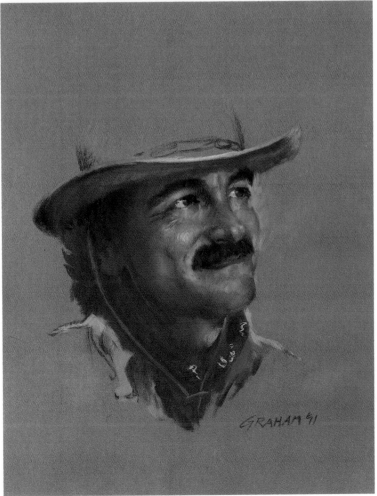

GALLERY OF PORTRAITS

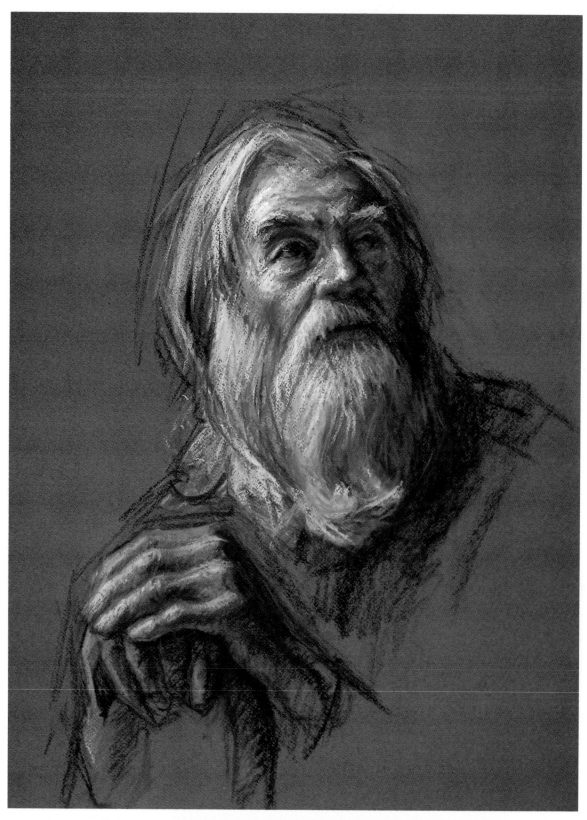

THE PATRIARCH, Foster Caddell, pastel on paper, 22″ × 16″. Private collection.

Caddell's luminous portrait of a bearded man illustrates how the interlacing of color strokes enlivens a portrait and enhances character. The artist has captured an expression of nobility and intelligence.

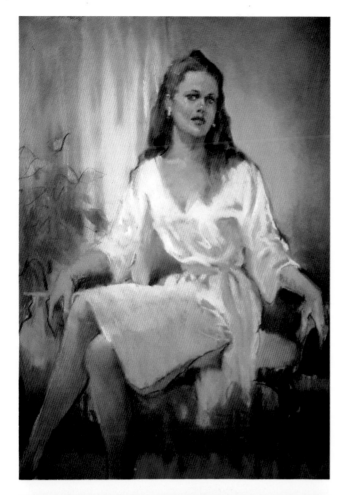

GIRL IN WHITE, Mary Sheean, pastel on paper, 40″ × 28″. Collection of Barbara Salvest.

Girl in White is an example of excellent space and color organization. In an almost illustrative, figurative painting, Sheean incorporates her hallmark bright pinks. Whites are warmly rendered, and the joining of edges on the model and drapery is a splendid example of lost and found edges.

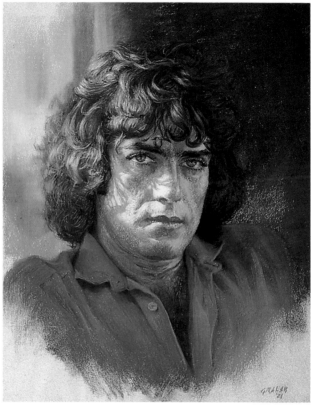

MAURICE, Bob Graham, pastel on paper, 20″ × 16″. Collection of the artist.

Graham uses the play of light and shadow on a strongly modeled face to create a strong and moody portrait. Note the tonal weaving of edges on the model and the use of a simplified background for drama and importance.

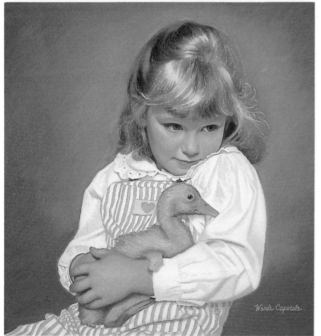

PORTRAIT OF KIT, Wende Caporale, pastel on paper, 24″ × 20″. Collection of the artist.

The shy personality of the little girl is captured with much attention to the melding of planes in the face and body. The blue background gives a complementary color frame to the nuances of pink and orange in the fleshtones.

THE STILL LIFE
EXPLORING DIFFERENT TECHNIQUES

A still life is the rediscovery of the familiar. When it is the subject of our paintings, we combine objects from our environment into new and unusual combinations. Mastering still life teaches an artist all the precepts of creating good art—drawing, tonal values, light and shadow, color, edges, positive and negative shapes, composition, space division and perspective.

The first concern in arranging a still life is always composition. It needs a focal point, using the arrangement of other secondary values and objects, lines and patterns to complement it and provide a visual path for the viewer's eye. Arranging and rearranging the still life can heighten your sensitivity to composition and design.

TECHNIQUES OF APPLYING PASTEL
There are many ways to apply pastel on the variety of available surfaces. Pastels, hard and soft, may be applied with the flat side of the pastel for coverage. The end of the pastel can create dots, dashes, lines, squiggles, directional strokes, crosshatching or combinations of all the above. The pressure of the pastel will affect the mark, as will rubbing it with the finger,

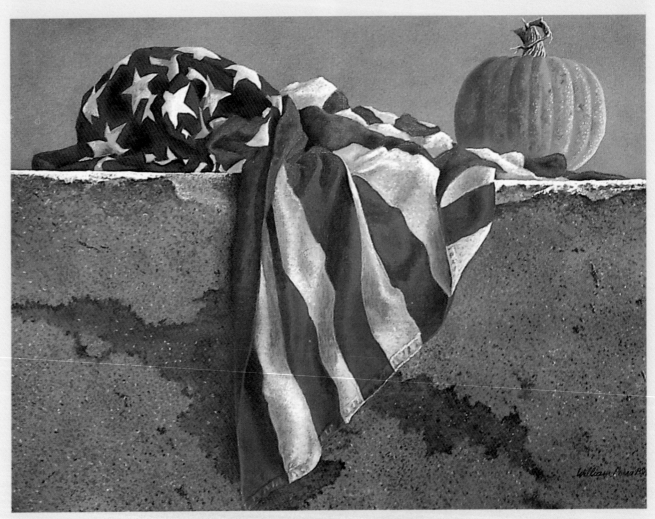

STARS AND STRIPES AND A PUMPKIN, William Persa, pastel
on paper, 20″×26″. Collection of the artist.

a stomp or tortillon, or a chamois.

Underpaintings made with an oil, watercolor, gouache, acrylic or pastel/turpentine wash create a toning value. It helps the artist establish composition and coloration, and often adds vibrancy to the finished pastel. Some artists do a complete color painting and work over it with layers of pastel.

FIXING AND EMBELLISHING THE IMAGE

Fixatives are generally used to bind the particles of pastel to the surface so that the fall of pastel dust will be minimized. The most commonly used is a "workable" fixative. A heavy application of fixative results in the pastel particles sticking to each other. The colors darken because the refraction of light is changed. Selective spraying to darken a passage can also be used. By keeping the sprayed layers underneath, an artist may leave the entire top layer jewel-like and without fixative. This seems to be the most popular use.

MATERIALS AND SURFACES

It is impossible to separate technique from the materials used and surfaces upon which it is done. There are an untold number of surfaces, texturing products, papers, matboards and museum boards, bristol boards, Masonite and pastel cloth. The roughness of a granular surface grips the pastel and makes it possible to use many layers. It also allows corrections to be made without losing the surface. Both toned papers and toned granular surfaces allow for much experimentation with the tone as a value, and often the tone remains in the finished pastel. With most granular boards, it is easy to eradicate an unpleasing composition, resurface it and begin again.

THE ARTISTS' INTERPRETATIONS

Although there may be dazzling techniques, those should be secondary to the development and placement of tonal values that will regulate the power of the image. The three artists in this chapter, working with different materials and techniques, show how a well-developed imagery is augmented by the technique of the artist and the chosen surface.

Anita Wolff, using fixative to layer thickly, shows a highly textural still life with vivid color and vigorous tonal contrasts. William Persa does two vibrant versions of the scene: One uses circular strokes of different values and colors to make a type of pointillism; the second is a highly realistic version of the image. Jill Bush emphasizes abstract qualities to create a bright, textural still life on sanded pastel canvas.

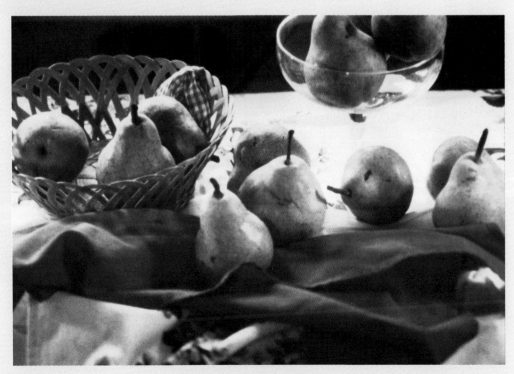

A SYMPHONY OF PEARS

91

ANITA WOLFF
Layering With Fixative for a Glowing Surface

Wolff's interpretation of the photo is impressionistic. She says, "The goal of this 'symphony' is to show luminosity of color." Preparing a master drawing on white drawing paper, she traces it and transfers the traced drawing to black Canson paper. She then works out a dynamic and moving composition, giving careful attention to patterns, a complementary color scheme, strong tonal values and a good directional light source. She creates a tactile and glowing finish by using multiple layers, each sprayed with fixative. Her recommendations for framing are a gold molding, semi-ornate and wide. To complement the blue in the painting, a wide silver molding would also be effective.

STEP 1: "I make a complete drawing of the subject, checking relationships of the still-life objects: napkins, fruit, basket and tablecloth. I then make a tracing of the drawing."

STEP 2: "The traced drawing is coated with orange pastel and taped chalk side down to the black Canson paper. The drawing is transferred by pressing down on the lines with a pencil."

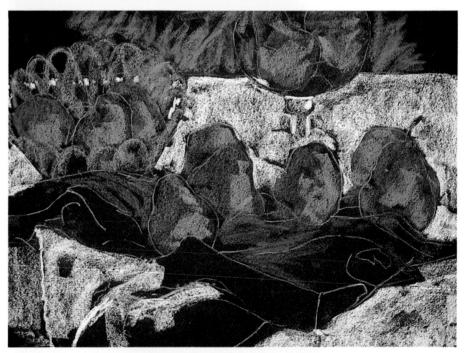

STEP 3: "With attention to lighting, I lay my pastels in flat to tone the picture, starting with the basket in a purple-brown, the pears with two shades of violet, a burnt sienna red for the napkin, and turquoise for the tablecloth."

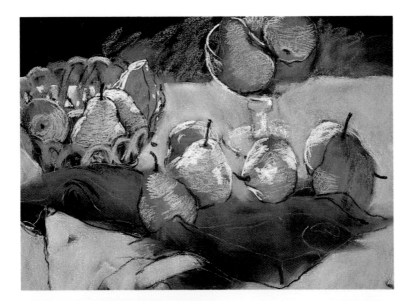

STEP 4: "I use a paper towel to wipe off excess pastel, and rub it into the textural tooth of the Canson paper. I use a black pastel to outline the fruit basket and other items."

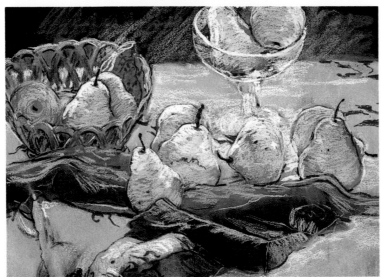

STEP 5: "I work over the underpainting of violet. The colors take on a glowing quality because of the complementary influence. I keep pastel strokes apart and continue working on the pears, basket and some of the pears on the table. I use a blue-gray on the glass compote and the tablecloth."

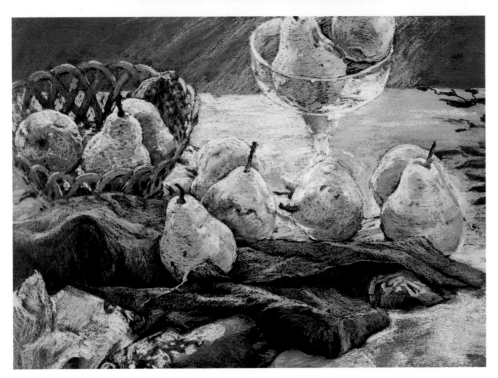

STEP 6: "Final details are laid in, and I make careful choices about emphasis and color change. The compote is now refined with Thalo blue. I work to make each piece of fruit glow. There are over fifteen separate color notes in the pears, which enhance the richness of the painting."

A SYMPHONY OF PEARS
14¾" × 19¾"

WILLIAM PERSA

Experimenting With Two Different Techniques: Two Views

This rural Pennsylvania artist thrives on painting the smallest detail of very intricate folds of cloth, architecture, flags and anything with a woody texture. The assignment to do two paintings using two different techniques is clearly enjoyable. Beginning with Ersta sanded paper, Persa rubs it with a medium gray alphacolor to attain a neutral starting base.

He uses a circular stroke technique and unblended complementary colors throughout the entire painting.

For version two, Persa, working again on Ersta sanded paper in his customary realistic manner, decides to use hard edges. He chooses complementary colors of purple and yellow. He intricately weaves color in the baskets, suggests clarity, hardness and shine in the goblet, and uses clear, rich colors to show the ripeness and succulent quality of the fruit.

For both versions of this colorful work, Persa recommends a triple white mat with a neutral frame.

STEP 1: "After experimenting with different stroke techniques, I use circular, unblended strokes and values. I start on the left side of the painting—pears first, napkin second, basket, tablecloth and finally the glass."

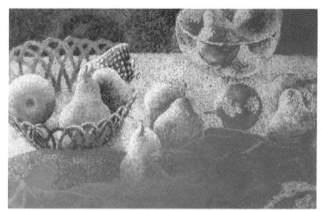

STEP 2: "I use bright red and green complementary colors in the fabric to create unusual effects. I add purple to the foreground fabric, refine the basket and develop the compote and pears. At this point I am very excited by this new technique and begin to visualize future paintings in this manner."

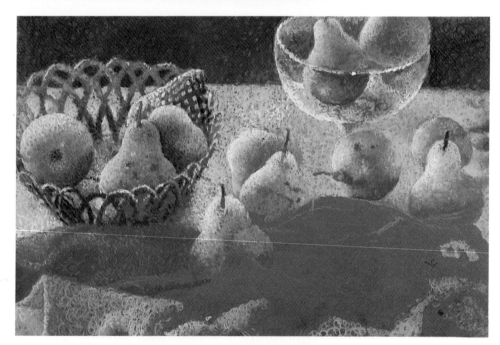

STEP 3: "I like to paint fabric very much. Painting the lights and shadows in the folds requires good basic drawing ability. Here I work on the purple foreground cloth and continue with the circular strokes."

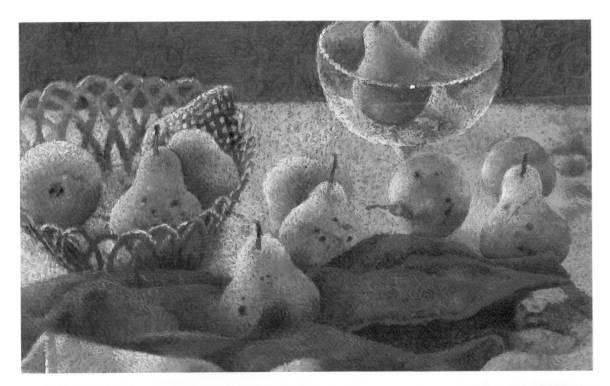

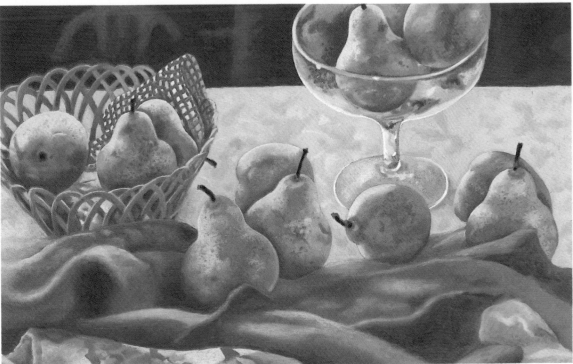

STEP 4 (TOP): "I add blemishes and scratches to the pears and complete the red cloth, letting the isolated red and complementary green strokes work together for a strong, visual effect."

A SYMPHONY OF PEARS
7½" × 11½"

VERSION 2 (ABOVE) Persa's second version is a more realistic rendering, has harder edges and employs a different application technique than his first version, but uses similar glowing complementary colors.

A SYMPHONY OF PEARS
7½" × 11½"

JILL BUSH
Abstract Qualities Create Dynamic Still Lifes

Bush works on Fredrix pastel canvas, stretched to a 19″ × 30″ size. This rough surface allows for beautiful layering of hard and soft pastels. She uses a wide and unlimited range of color. She says, "What is a symphony without all the notes? I chose the colors because I want a lively symphony—with harmony and variations."

Having done preliminary drawings, she begins abstractly, using gathered props to help visualization. These include a straw basket, an embroidered tablecloth, a teal napkin and a variety of pears.

Bush designs a luscious light pattern to emphasize and control movement of the viewer's eye in the painting. She states, "Because of the deep, rich color and strong contrast, this painting has a jewel-like quality. Like a symphony, it has softness, sharpness, rhythm and rest. I strive for all these qualities and they seem to call for this strong light/dark interpretation and high-key color."

The artist suggests a white linen liner, and a gold tone or wooden frame.

STEP 1: "I work to define the abstract organization of shapes, colors and values. If all shapes in a composition are energetic, as opposed to static, varied and interesting as opposed to monotonous, the still life will be dynamic. My preliminary photocopies, sketches and color studies are used to alter the working image."

STEP 2: "Working from my preliminaries, I sketch in a loose, angular manner with a red-violet pastel Conté pencil on stretched pastel canvas. I move and remove pears and plan the composition with some adjustment of angles."

STEP 3: "My color palette includes deep burnt sienna, violet, cobalt blue, light reds and green umber, dark blue-green, cerulean, deep violet, yellow-green, orange, red-orange and carmine. Color notes are placed everywhere. I work with a methyl-cellulose solution that I use for making pastels, and titanium white pigment for corrections and alterations on the rough surface. I use deep blue-violets in the shadows of the napkins, and blue-green, as well as white, to blend with the medium."

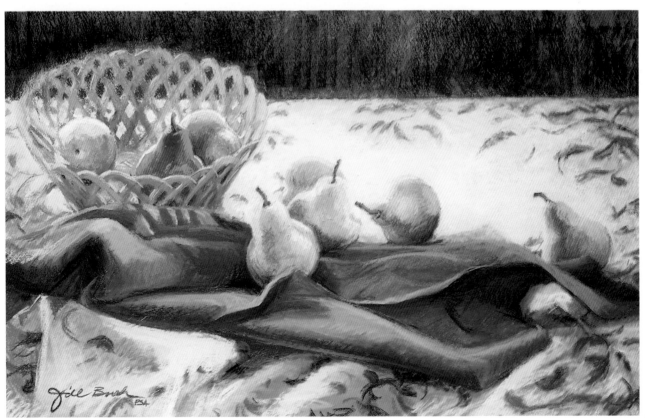

STEP 4: "I refine the basket using umbers and add a red blush to the pears. The pear colors range from red-orange to red-violet and yellow-greens through blue-greens. Correcting the table edge with a chalk line, I drop color through the background with blue-green, blue and violets over the tablecloth. I begin to put the pattern on the tablecloth, and fine tune it with violet and burnt sienna. Further detailing would take away from the abstract quality."

A SYMPHONY OF PEARS
18″ × 30″

GALLERY OF STILL LIFES

10 O'CLOCK BASKETS
Margot Schulzke, pastel on
pumice board, 18″ × 24″.
Collection of the artist.

Schulzke creates a vibrant
still life with textured bas-
kets, complemented by the
surrounding colors of the
fabric. Analogous colors of
the brick wall and baskets,
along with split complemen-
tary colors of other pictorial
elements, give the composi-
tion sparkle. The rough sur-
face of the pumice board is
well-chosen for this textural
rendering.

MORNING TABLE, Judy Pelt,
pastel on pumice board,
22″ × 28″. Collection of the
artist.

Pelt's bright and cheerful
pastel illustrates many of
the requisites of a painterly
still life. It is thematic, and
its vibrant complements of
orange and blue, and yellow
and purple, along with the
use of good tonal values,
create a glowing but tran-
quil mood. The rough tex-
ture of the pumice board
imbues it with textural in-
terest.

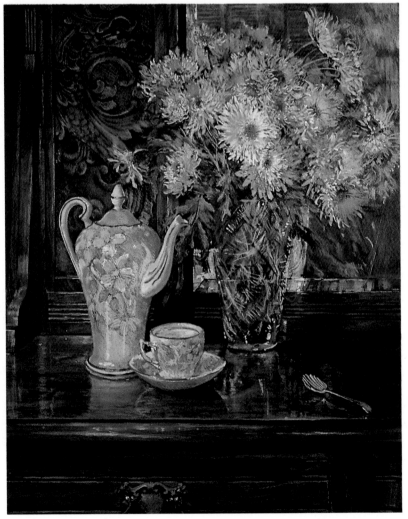

WOODPILE ON A SCHNECKSVILLE FARM William Persa, pastel on paper, 20″ × 26″. Private collection.

Persa's work is often a still life study of some treasured objects or scene. This one is thematic, colorful and textural, with good tonal values and contrasts. What could be a confusing welter of sticks and wood becomes a beautiful study of textures, shapes and curves and a luminous light pattern.

ENGLISH TEA SET, Anita Wolff, pastel on paper, 28″ × 22″. Private collection.

Wolff's charming thematic still life is painterly and beautiful. She does the woody textures and carving with authority, adding richness to the objects. The purple flowers and yellow tea set are complementary colors that make it visually exciting. She builds textural thickness by layering and spraying, except for the final layer.

INTERIORS
OBSERVING TONAL VALUES

Tonal values, the relative lightness or darkness of a tone or color, act as the skeletal structure upon which a painting is built. Just as there are many shades of gray, from white to black, every color's shade has an equivalent gray value, from the very lightest yellow to the darkest purple close to black. Understanding values enables you to interpret what you see to give credence to your compositions. Anything receiving light has a value. Not only does an object have local or intrinsic color, it also has a degree of lightness or darkness of that color. For this reason, it's a good idea to use painting with a relative value scale until you are experienced enough to intuitively judge values correctly.

ESTABLISHING VALUES

Although you can probably get fifteen to twenty values of most colors, artists probably work on a scale containing around five to ten values. At first, it's helpful to establish a simple value scale of five, going from white to black, with light, medium and dark values of gray in between. The range and pattern of a picture's values are usually best determined in the thumbnail or color/value sketches that many artists

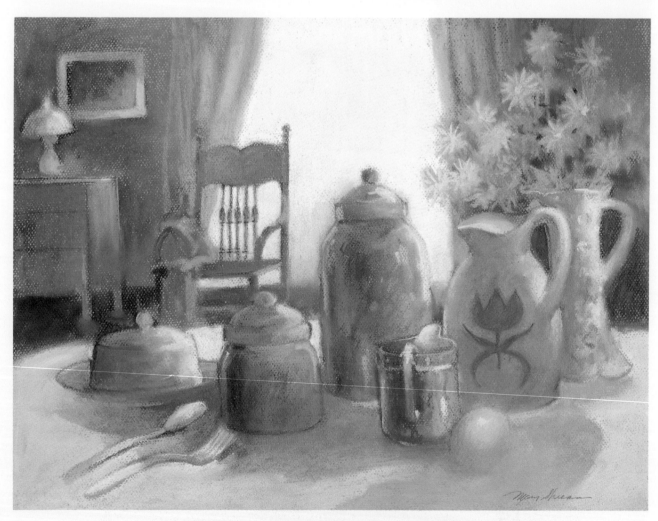

TEA TIME, Mary Sheean, pastel on paper, 15" × 18¾"

make before working on a pastel. It is a simple way to assign value to the larger masses, and then rearrange or manipulate those values. There are also subtle values tones within light and shadow. Knowing how dark to go in the lights, and how light to go in the darks is an important part of the versatile vocabulary of pastel. It is like knowing the words to a song, allowing you to create an artistic melody.

One way to get a handle on values is to decide whether a picture will be in a high or low key. A high-key picture emphasizes the light, bright end of the value scale. A low-key picture is darker and often cooler. Once you decide what key to use, you can concentrate on the relative differences in lightness and darkness within the value key to help construct a pictorial mood.

TRANSLATING BLACK AND WHITE TO COLOR

Most pastel artists are colorists, and the propensity is to make color the most prominent feature, with all other considerations secondary. Without some kind of planning for tonal values, the pastelist often spends much time correcting and redoing the painting. Planning values can help achieve a balanced pattern of lights and darks which can be interpreted into color. It is very helpful to work out a black-and-white thumbnail in approximately five to seven values. This provides a format for working out color decisions. You can then match color values to each value in your black-and-white thumbnail.

INTERIORS

Interiors are a specific type of genre painting—one that usually reflects a scene of everyday living. In this chapter, the artists are challenged to create an intimate, darkly valued interior, with filtered light streaming from one side through a lace-curtained window. This lighting creates long, dark shadows and ambient light that falls on a table set with antique pitchers and dinnerware. The late afternoon light profoundly affects the tonal values of the room. The antique high chair evokes a sentimental mood of a bygone era.

THE ARTISTS' INTERPRETATIONS

Because of the preponderance of darks and the crowded number of objects, most chapter artists felt that rearrangement and selection of objects was in order. Jill Bush creates two mysterious, shadowy versions of the same scene. One shows the entire sunstruck scene, while the other shows a more tactile closeup of some objects. Tim Gaydos rearranges all objects, uses a complementary color scheme, creates texture, and floods the scene with sunlight. Foster Caddell, with a major rearrangement of objects, creates an intimate table scene with a subdued palette of beautiful low-key color.

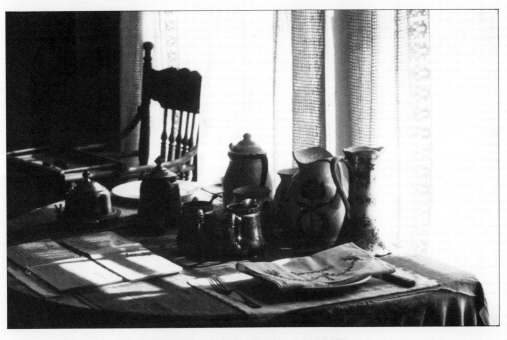

TIMELESS ROOM, PRECIOUS OBJECTS

TIM GAYDOS
Enhance the Mood With Contrasting Values

Working on oversize, dark gray Canson Mi-Teintes pastel paper with Rembrandt, Sennelier and Grumbacher soft pastels, Gaydos moves the objects to attain a strong abstract pattern. He states, "I choose warm and subdued colors to evoke the feeling of nostalgia, quiet and the filtered light of the photograph." He rearranges the crowded composition to eliminate objects, and introduces new elements into the pastel. The windows are designed as the only source of light, as he seeks to create strong light and shadow contrasts in his work.

For framing Gaydos suggests the following: a brown wooden frame with a 3″ white linen liner, or alternately, a natural wooden frame with a 3½″ warm gray outer mat and a ³⁄₁₆″ ivory inner mat.

STEP 1: "After moving objects and completing thumbnail value sketches, I place the drawing on the gray Canson paper with charcoal. This is basically a map of color areas."

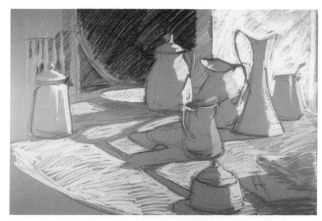

STEP 2: "I lay in darks and lights to create a pattern, and decide to make the lower right corner dark to make the light pattern more interesting. I postpone making color decisions."

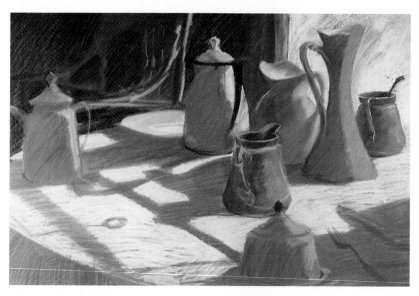

STEP 3: "I extend the painting to the right for better balance and reverse the high chair back to the original position to promote rhythm. I decide on a warm color scheme and add reds and pinks to give contrast to the focal point."

STEP 4: "I continue changing and refining shapes and colors. The colors in the curtain are light cobalt blue, raw umber and a very light yellow. All the vessels receive more color in the light and shadow sides. The brass I render in Prussian blue, ochres, burnt umber, English red and olive green."

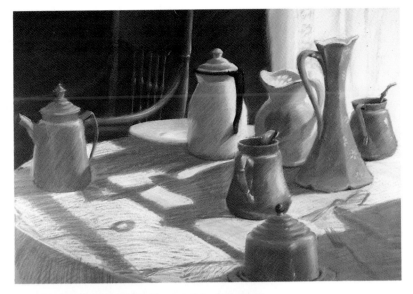

STEP 5: "I am not happy with the vessels in front. They do not have interesting enough shapes to hold such an important place in the composition. I substitute a jug and teapot and add dried grasses and flowers to give some life and variation to the collection of vessels. I eliminate the shadows of window sashes because they run in the same direction as the stripes on the table-cloth."

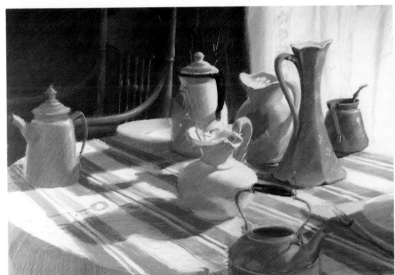

STEP 6: "Finishing touches include refining the table-cloth and shadows, and turning the pot on the left side more to the left to contrast with the other vessels. I add Japanese lanterns to the center jug and make corrections in the chair."

TIMELESS ROOM, PRECIOUS OBJECTS 25" × 34"

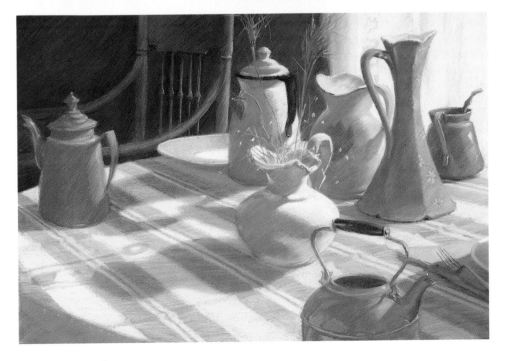

JILL BUSH

Good Value Patterns Strengthen a Composition: Two Views

Bush does her first version on prepared 100 percent rag board (dusky rose), textured with Res-N-Gel and Pyrotrol. Pyrotrol is the brand name for pyrophyllite, a member of a large family of hydrous alumina silicates used to make clay and porcelain products. The Res-N-Gel is rolled on and the Pyrotrol is sifted on while the surface is wet. Then the surface grit is dusted evenly over the surface. She uses the photo as a value study and has it made into a laser print. She studied the photo intermittently for a month to consider how she would make changes. She states, "The colors suggested themselves—lavender and old lace—a woman's things—traces of her life. It shows the warmth (sunlight) she must have brought to her family and the softness and comfort that was hers to give." Making corrections in the divisions and proportions of lights and darks to alleviate overcrowding, and eliminating some objects,

she works to develop a soft-edged painting to reflect the overall mood.

Bush works on her second version with the same preselected assortment of pastels. Her working surface is stretched Fredrix pastel canvas, and she renders a slightly cooler version. She zooms in on one section of the photo and eliminates the dark background and the high chair. She says, "I wanted the feeling of a cool morning before the day's activities and the warmth of kitchen fires—the breakfast table that greets you when you first get up on a sunny winter's day."

Bush suggests a 1¾" wide silver frame with rosy red mottled finish and a carved lip, and ¾" wood liner covered with white linen. An alternate framing would be 2" wide gold, mottled finish with carved lip and a ¾" wood liner covered with a natural linen.

STEP 1: "Using vine charcoal, I place in my drawing and develop negative shapes. I use the charcoal to establish midtones and darks. I also introduce caput mortuum, which is close to the hue of the board, and a lighter value for clarification of lights on the handles of the collected objects."

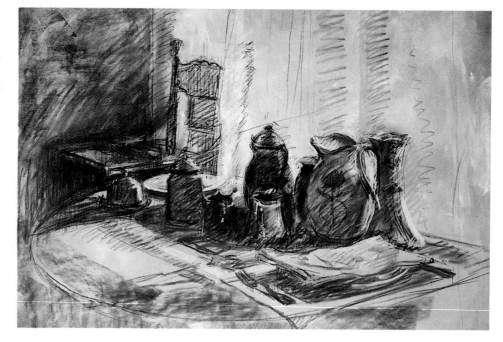

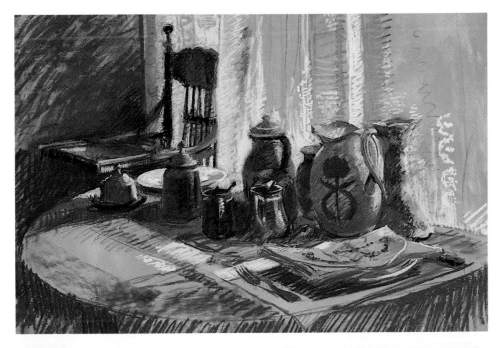

STEP 2: "With the intention of keeping my palette subdued, I begin choosing colors for the chair (sienna and violet), tablecloth and vase (whites and off-white), pinks for the roses, soft greens, gold, reds and blue for the coffeepot. I stroke the pewter items with gray-violets and greenish-yellow umbers, and work on the handle of the coffeepot with indigo and light gray-violet. The shadow pattern falling across the table acts as a halftone. At the lower left I darken the shadow with dark purple-gray to create a mystery. I develop light areas with Sennelier pale violet and work medium value purple-brown for the table midtones. Rembrandt red-violet is used for the table edge, the vertical shadow between the curtain and wall, and to illuminate the chair."

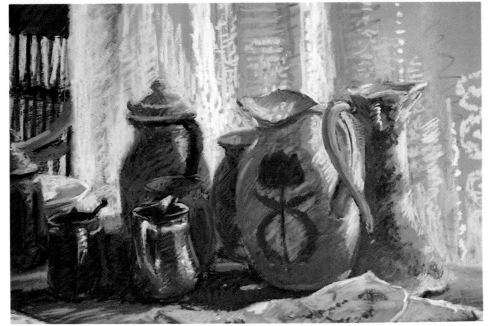

STEP 3: "Correcting drawing errors, I continue developing light and shadow patterns on the table and the illusion of the folded napkin. Sennelier pastel in pale, clear peach is used for bright reflections, edges of napkins and the brightest, glowing light filtering through the curtain."

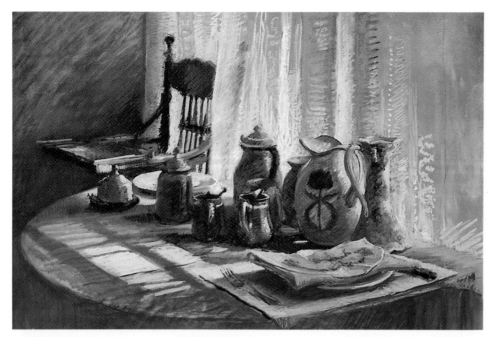

STEP 4: "At this point, I discover that all colors need intensifying. I put flesh and peach tones into the curtains, Nupastel blues for the inside of the large pitcher and improve color in all parts of the picture. To remove the somewhat monochromatic look, I work pinks, red-violets and blue-violets into the shadows. The picture is taking on a late afternoon quality."

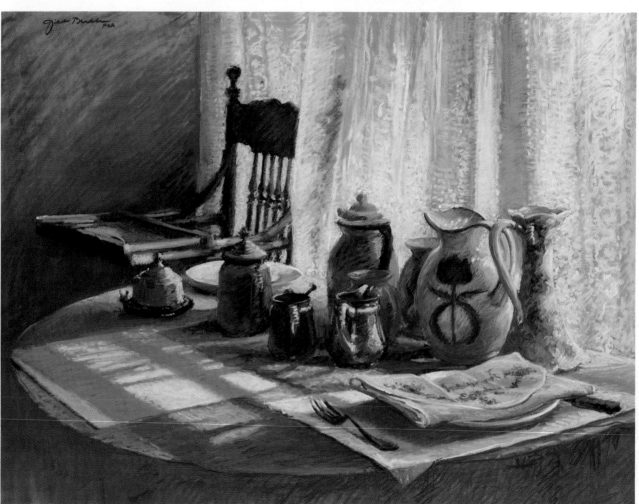

STEP 5: "Even though the palette for this painting included 115 pastels, I feel I have maintained a strong value pattern throughout the evolution of this painting. For the final step, I make last-minute adjustments of drawing, color, light and shadow patterns, and I lose and find edges. At last, I use large mat corners to look at the finished pastel."

TIMELESS ROOM,
PRECIOUS OBJECTS
20½″ × 30″

VERSION 2

STEP 1: "Working from the preliminary altered photocopy, I block in the masses with a violet Le Franc pastel of medium hardness. I block in the masses, cutting into them with titanium white pigment and turps substitute (a turpentine substitute that cuts fumes and odor). Then I push and pull shapes to place the composition."

STEP 2: "I work in cool analogous color combinations of blue-green through red-violet, enlivened by small touches of their complements or split complements. My colors are purer in hue for the second version, as I have used few grays or umbers."

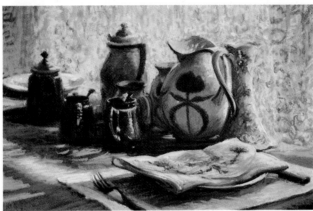

STEP 3 (BELOW): "Many subtle touches are completed in this layer. I place highlights on the creamer and reshape tops of vessels and vases. With slight corrections to the drawing and color, I bring it to a close."

TIMELESS ROOM,
PRECIOUS OBJECTS
12" × 18"

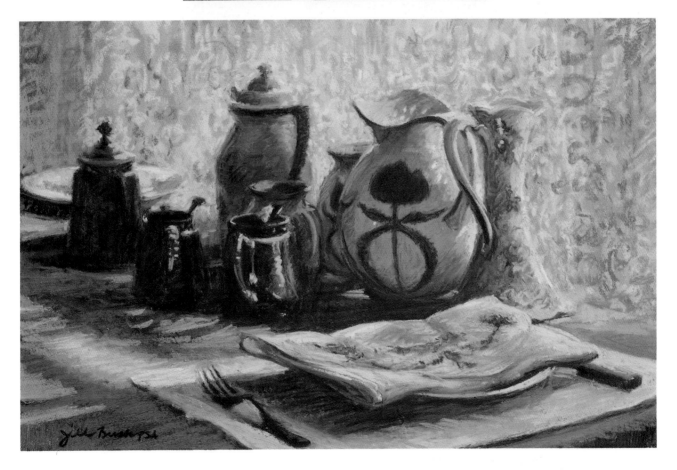

FOSTER CADDELL

Subdued Color Values Create an Intimate Scene

Using Canson dark brown paper to develop the rustic charm of the scene, Caddell departs from the photograph to reassemble the scene. He rearranges the objects into a more open composition with light drifting across the table. Using a carefully worked drawing placed in a light pastel on dark paper, he develops the major value range and a strong abstract pattern to give the pastel beauty and authenticity. Caddell says, "Although I have never made a true abstract painting, I believe in the importance of abstract design. Art is a means of communicating to the public, and my work always has interesting subject matter."

STEP 1: "In keeping with the rustic charm of the subject, I choose to work on Canson paper with Sennelier pastels. Sketching with great freedom, I aim for good design and placement of objects, rather than specific delineation."

STEP 2: "After designing the subject, I establish the main value range. I am intrigued by the large area of light coming in the window through the curtains. I cover the paper with a layer of pastel to tone down the dark brown color, and introduce warm tones across the table and cool areas in the crockery on the right."

STEP 3: "I carry the image further and develop the variations of color. I imagine some foliage outside the window to give green to the light mass. I keep the ellipse at the top of the vase at right angles to the axis of the object. The whole butter dish on the left is drawn, even though some of it will be cropped."

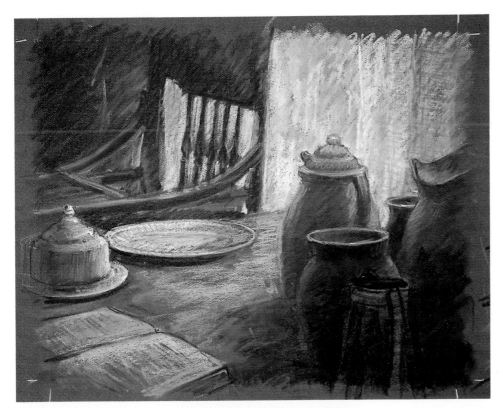

STEP 4: "Aiming for a greater sense of form and subdued values, I use the full range with black on the right foreground. All objects are developed with a sense of where the light is coming from. It is one of the most important elements in depicting reality. The book on the left thrusts diagonally to direct the viewer's eye back into the picture."

STEP 5: "In this final stage I have brought everything to the conclusion that I feel the subject deserves. Colors in the crockery are deepened and highlights around the rim of the foreground pitcher reflect the window light, which gives even this one small section a full range of tonal values."

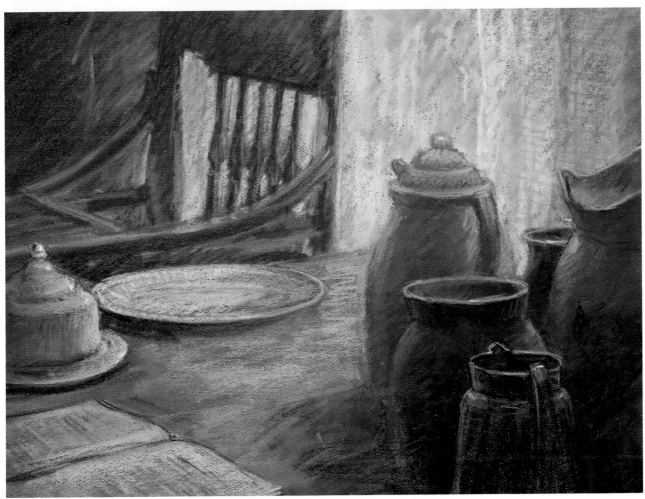

TIMELESS ROOM, PRECIOUS OBJECTS, 16″ × 20″

GALLERY OF INTERIORS

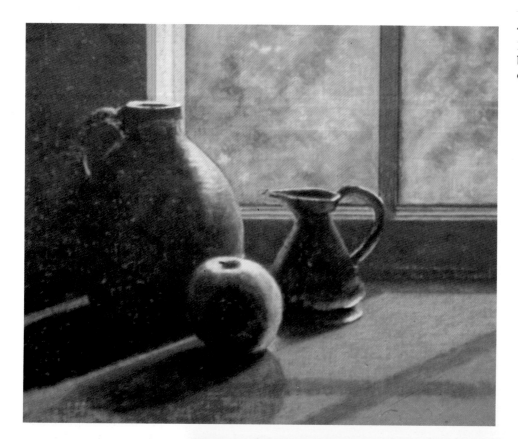

THE GREEN APPLE
Elizabeth Mowry, pastel on
board, 29″ × 35″. Collection
of the artist.

THEATRE MORNING, Tim
Gaydos, pastel on paper,
24″ × 36″. Private collection.

Gaydos's *Theatre Morning* is
a strong example of a tonal
composition in a low key.
Adding life are the comple-
mentary and split comple-
mentary colors of red-
purple, purple and yellows.
With colors close to black on
the tonal scale, this is a sub-
dued, yet glowing interior.

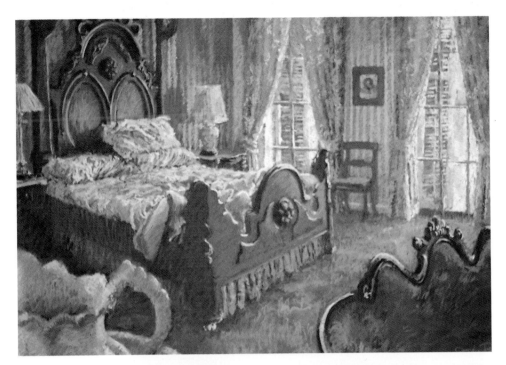

THE INTERIOR, Judy Pelt, pastel on board, 22" × 28". Private collection.

This sunwashed bedroom interior, done in warm middle-to-high values, has sumptuous textures in the wood of the bed, velour of the carpet and transparency of the draperies. The thickly applied pastel enhances the overall light quality, while the medium darks promote color harmony. The burnt sienna/blue combination adds vibrance.

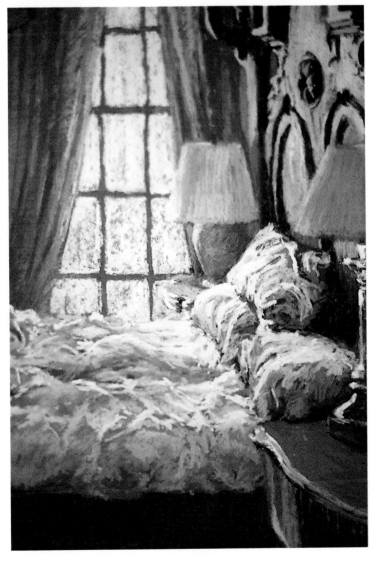

SATURDAY MORNING Judy Pelt, pastel on board, 36" × 24". Private collection.

Pelt's interior is a light-filled, high-key pastel in red, orange and yellow color values. Complementary purples and yellows add resonance to the many fabric and wood textures. The very dark accents and shadows of the table and pillow keep the focal point of the triangle at the window, lamp and bed pillow.

TEN

HARBOR SCENES

LOOKING FOR ABSTRACT PATTERNS

The abstract patterns in a harbor scene are often strong and easily identifiable. The boats in this chapter's photograph are rowboats or dinghies, mainly used for transportation to the larger fishing or lobster boats of the East Coast. This particular picture is from the shore of Rockport, Massachusetts. Dark and colorful cast shadows add to the abstract qualities of the boat grouping and solidify the image by anchoring the boats to the water. The colors of the boats range from white to purple, and several have that multilayered worn and repainted look—all nice elements for creating a beautiful abstract design within your painting.

The choppy, curvilinear quality of moving water causes the boats to rock and swing around—overlapping and rearranging themselves into pleasing shapes, spaces and shadows. It's no wonder boats are easy to paint over and over again, as they never appear in quite the same configuration twice.

EXPLORE LIGHT AND SHADOW PATTERNS

In this instance a lone boat was cast on the shore—a soloist with the chorus of boats arranged around it in a semicircle. Multicolored stones and shoreline debris form a background, casting colorful reflections into the water. The sun bouncing from the boats also creates exciting color and value changes within the boats. If you have admired boat imagery, it is probably because of the naturally beautiful, abstract connections between the boats and their surroundings.

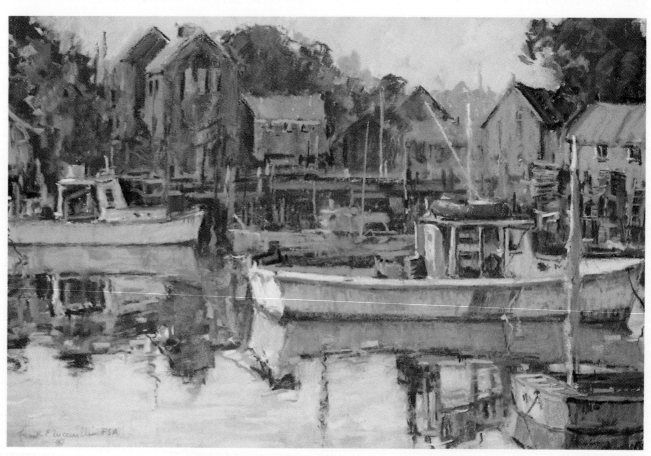

BOATS AT REST, Frank Zuccarelli, pastel on pumice board,
20″ × 24″. Collection of Dr. and Mrs. Martin Borsky.

LOOK FOR SHAPES

This particular scene lends itself to painting small, sparkling shapes in the boats, land and water. The larger shapes seem to divide themselves naturally into smaller abstract shapes—and there is a strong interplay of light, shadow and color on every surface. Although the sky is not in the photograph, it is evident in the reflections and color changes. Elements that may be added to harbor scenes include sea gulls, people, shorelines and sand, land structures and buildings. All of these parts can be combined to create painterly lights and shadows, reflections and the resultant abstract patterns.

THE ARTISTS' INTERPRETATIONS

The three artists in this chapter approach the photograph differently. Madlyn-Ann C. Woolwich creates a moody, monochromatic pastel with a low-key palette and a subtle use of complementary colors. Frank Zuccarelli divides the boat group and departs from a literal depiction to place himself at a distance from the boat configuration. Casting the scene on a gray day, he subdues his colors to a neutral value, and creates an atmospheric and overcast scene with strong reflections. Judy Pelt, working mostly in a high-key color range, creates two different sunstruck impressionistic renditions. The first version pictures all the colorful boats swinging in an arc on the textured and iridescent water. The second version transports us to the Caribbean and a scene of separated boats attached to a floating wharf. The textural combinations of blues, greens and turquoises in the water allow the viewer's eye to combine the colors for great vibrancy.

BOATS AT ROCKPORT

MADLYN-ANN C. WOOLWICH

Connect Dark Shapes to Integrate the Picture

Having always lived on the shore, Woolwich is inspired by the sparkle of sun, the glint of water, the textures of rocks and sand, and the curvilinear shapes and thrusts of waves and boats. After examining the black-and-white photograph, she decides to use the entire composition. Its intrinsic light and dark patterns are strong and will provide painterly subject matter. Envisioning a somewhat warm, but monochromatic color scheme, Woolwich draws a series of pen-and-ink sketches to master the direction and structure of the boats. The final one is photocopied in multiples to create different color schemes. Working on archival four-ply museum board, surfaced with diatomaceous earth, gesso and acrylic paint, she lays the drawing down with charcoal and reinforces it with an acrylic line drawing. She follows with acrylic washes which will place in local color of the scene.

She plans to use the surrounding stone-covered shores, the distant and dark backwater ripples and the darkly shadowed underside of the dock, and will close the square by darkening the lower right side. This shadow frame will act as a conduit to the focal point—the two white rowboats in front. She begins with a highly chromatic series of underpaintings using acrylic paints, followed by layers of hard and soft pastel. She tones and cools these colors down in the final coat.

Woolwich suggests framing this pastel with a carved wooden frame 1″ wide in a combination gold and silver color, and 4″ off-white mat with a ¼″ liner matched to the mauve or blue of the picture. An alternative framing would be a silver wood frame, 1″ wide with a 3″ white linen liner.

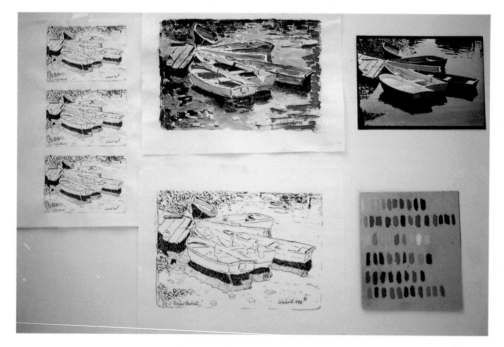

STEP 1: "First I plan my drawing and color scheme. The drawing is in pen and ink, and the preparatory color comp shows the planned color scheme. The original sketch was photocopied and various color combinations were tried. All the colors I decide to use in the pastel are also recorded on sanded paper. In the color comp, I connect dark boat patterns together and try to develop the same intensity in both the land and the water."

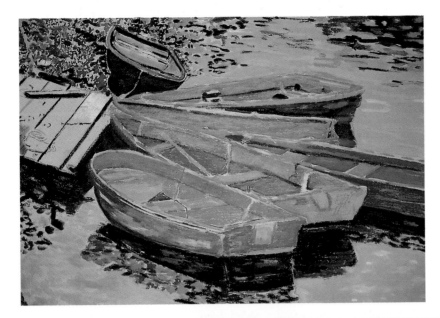

STEP 2: "On a prepared pumice board, I do a simple charcoal drawing, which I go over and fix with purple acrylic paint. This is followed by an acrylic layer to wash in the underpainting and the local colors of the subject. Note that the darks are kept highly developed. This is one of the ways that abstract patterns are developed to strengthen any composition."

STEP 3: "With Nupastels I develop a complete underpainting, working with color that will add vivacity and vibration to the final upper coats of soft pastel."

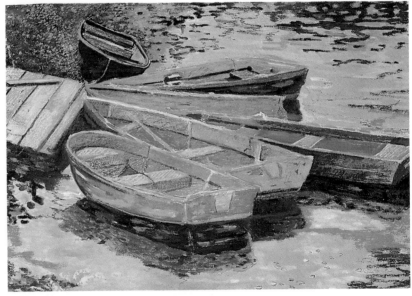

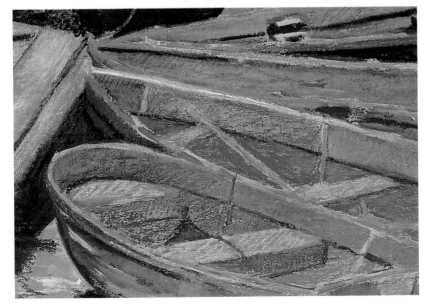

STEP 4: "I use a technique of random stroking to add excitement, light and a strong note of color, which will echo underneath the somewhat white exterior of the rowboats. Darks surround the sea and shore and define the boat interiors."

STEP 5: "I work with Rembrandt and Grumbacher pastels for the second and third layers, and tone down the colors to show a cooler scene. The development of strong linear effects in the water guarantees that it will be water with personality instead of a broad, blue expanse."

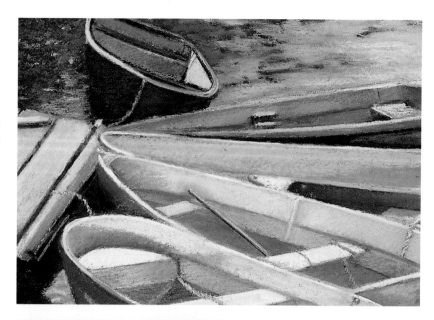

STEP 6: "Brighter colors are added to the back of the boats and the ripples in the water. The dark water patterns cause a connection between the water and the darks in the boat group."

STEP 7: "The top layer is developed with the softest of pastels—Sennelier, Rowney and Schmincke. Bouncing in broken color gives the scene an impressionistic quality. The distribution of darks, coupled with color spotting, keeps the eyes focused on the boats."

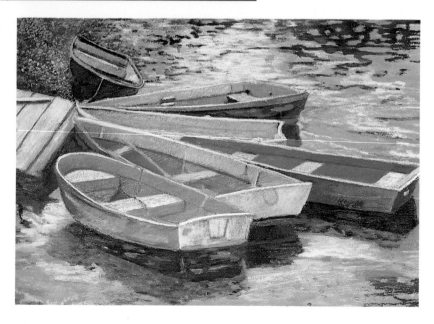

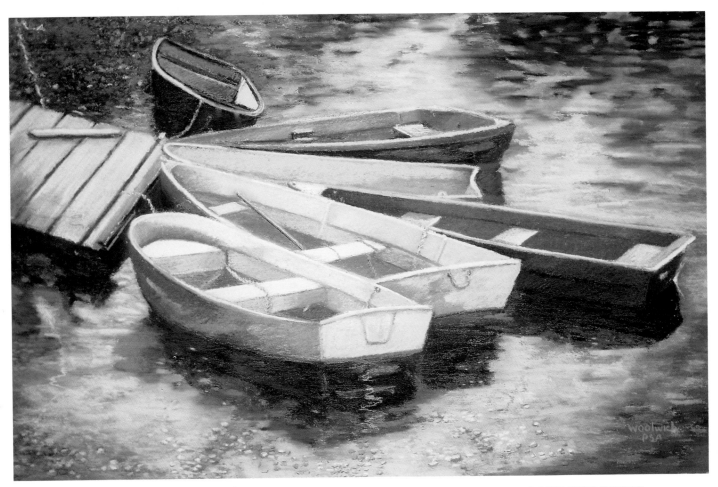

STEP 8: "All colors are reworked, highlights are brightened and darks reinforced, and the stone pattern of the shore is strengthened. All changes are made to enhance the quality of the filtered light in a tranquil scene. The boats are all in a rhythmic circle with each one part of the harmonious whole."

BOATS AT ROCKPORT
28″ × 38″

FRANK ZUCCARELLI
Using Reflections as Abstract Patterns

Zuccarelli works on Crescent watercolor board, surfaced and primed with gesso and pumice. He visualizes a cloudy day with a bright, overcast sky, and handles the values as simple masses. The darkest darks are placed in the smallest areas. The lights and halftones dominate.

He states, "Rather than copy the photo, I paint my impression of the scene. With the elimination of one boat, I enlarge the space and can introduce some motion into the water. I do not work in brilliant colors because of the subdued mood of the day. I use various tones of grays, dull greens, tans, brown and dulled reds."

Zuccarelli creates a problem when he changes the spatial perspective by moving himself back in space. This requires a change in the shape and size of the boats. The added space allows him to introduce some building reflections into the water. He feels suggestion is more powerful than precision, and imagination is the key to avoid being a slave to the subject.

His suggestions for framing are a silver frame, a medium blue, V-cut mat with a white liner, or a slightly rustic wood frame with light gray patina and the same blue and white matting.

STEP 1: "The first sketch with a felt-tip pen is strictly experimental. I make changes in the boats, shoreline and reflections."

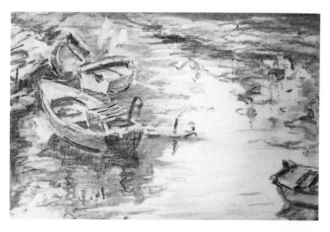

STEP 2: "I do this small charcoal study before tackling the larger finished pastel. I establish the main focus at the three boats near the wooden landing. For interesting conflict or design, the boats are pointed in opposite directions. Another boat is placed in the lower right. The large reflection in the water acts as a unifying element in the picture."

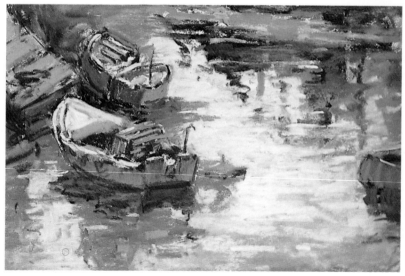

STEP 3: "With Nupastels, I do a color comp. Aiming for subtle, sharp contrasts of values with reflections, I strive for vibrant color, and for color balance I introduce warm values into cool areas."

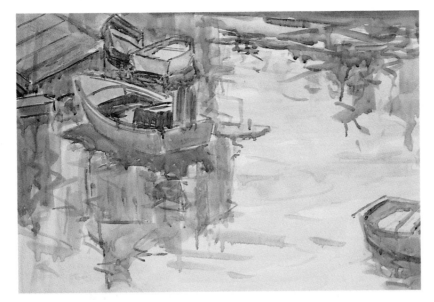

STEP 4: "On a gesso-pumice board that I prepare myself, I apply transparent washes of Grumbacher Hyplar acrylics in a loose manner. Color and value, the interaction of the patterns made by the boats and the reflections in the water make up the whole painting. Edges and textures are disregarded with the washes."

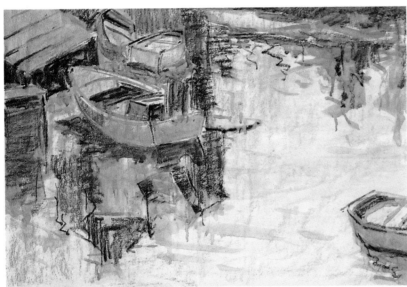

STEP 5: "With the flat side of the Nupastel, pale touches of blues, greens, grays and some warm colors are broadly applied all over the acrylic washes. This acts as an underpainting. With Nupastel #363 (a dark sepia or burnt umber color), some major patterns are blocked in and emphasized. The surface is sprayed with workable fixative."

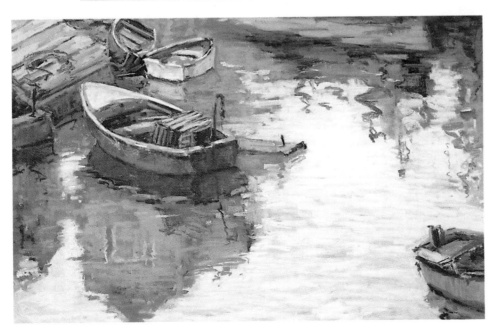

STEP 6: "Working to a finish by glazing and layering pastels, I jump back and forth between Nupastels for sharp edges, and Derwents and Rembrandts. The reflections are kept fairly cool and neutral. Getting the shimmering effect is very important. I exaggerate slight movement of water. The edges of horizontal strokes in the water are kept soft. For balance, reds are repeated in other areas. I spray very carefully and glaze over very lightly to cool down and warm up some areas."

BOATS AT ROCKPORT
12″ × 18″

JUDY PELT
Develop an Overall Image With Light Patterns: Two Views

Using Fredrix pastel canvas as a working surface, Pelt underpaints with oil and turpentine, and builds her boat pictures with a mixture of integrated hard and soft pastels. She puts the water in mid-values and lights, while the boats run the whole value range. With an intense interest in light patterns, she adds broken color in an impressionistic manner.

The first interpretive approach shows hints of evening light. She says, "I've spent many years observing what effect the time of day and the quality of light has on various subjects—grass, trees, water, etc. In a way you could say that I've prepared for this painting for years. All edges in the water are soft, even when the light merges into the dark. Hard edges are contained in the dock (to stop the eye) and in the edges of the boats. The sharp angles and values, as well as the flat light on the top of the boats, direct the eye, and the shadow shapes complete the abstract patterns."

For her second interpretation, Pelt crops out some details and introduces more movement and vivid color into the water.

Pelt recommends framing the first version in a soft gold-silver frame with an off-white 3″ linen liner or a whitewashed wood with an off-white double mat. For version two, she suggests white on white framing, or a gold cap frame with a 3″ liner.

STEP 1: "I tone the canvas with an oil wash made with jaune brilliant, and a little cadmium red and cobalt violet is placed at the bottom. With directional strokes I block in negative shapes, brush the shadow shapes, soften the edges and solidify abstract patterns. Scumbling medium value colors into the boats, I introduce a warmer green over the green boat, Thalo blues at the end of the purple boat and various other colors. Light violet and pinks are introduced into the dock and water."

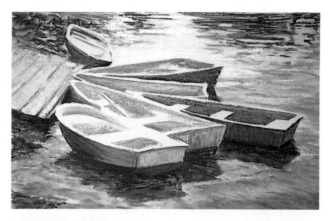

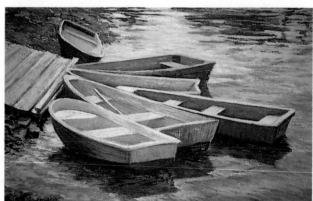

STEP 2: "The colors for the bases of the boats appear garish at first with red-violet, oranges and blue-greens. The superior tooth of this surface will allow me to scumble, tone down and achieve a glow. I correct the upper boats and scumble the too vivid boats with yellows, oranges and light greens. The dock gets a glaze of pinks, yellows and light red-violet."

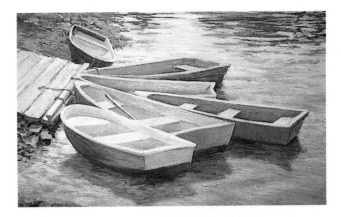

STEP 3: "The boat reflections are softened and some of their local color is moved into the water. The pebbled surface beneath the water is suggested. The boats are tied down with pieces of rope. I check values and head for a finish."

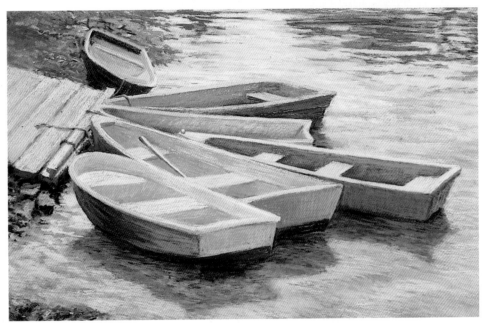

STEP 4: "The finished painting shows the last-minute color and value adjustments, and I hope it has produced a strong painting rather than a picturesque one. I have used 105 different pastels in this painting."

BOATS AT ROCKPORT
18″ × 27″

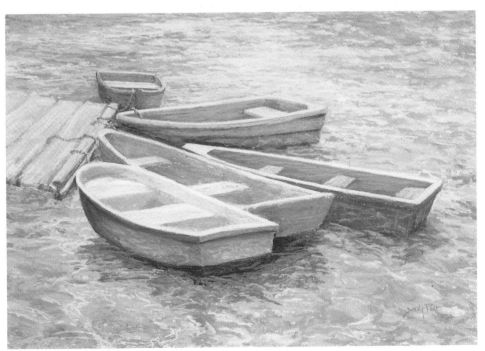

VERSION 2
Working on the same pastel canvas, Pelt develops a different composition from the same material, cropping out details and introducing movement and vivid Caribbean color into the water.

BAHAMA BOATS, 20½″ × 30″

GALLERY OF HARBOR SCENES

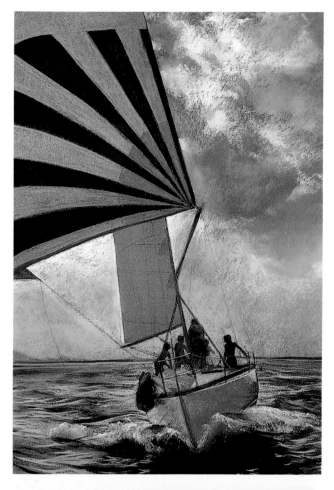

DRIVING HARD, Larry Blovits, pastel on paper, 22½″ × 17″. Private collection.

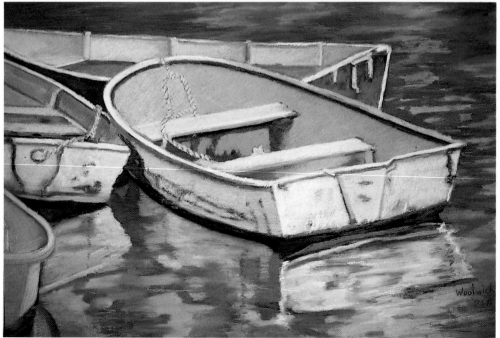

ROCKPORT ROWBOATS IV Madlyn-Ann C. Woolwich, pastel on pumice board, 20″ × 28″. Collection of Kimberly Crawford, M.D.

Woolwich's colorful and toothy pastel is a good example of her boat painting. With lively reflections in the water and cast shadows, it is another example of the white boats she often uses for imagery.

BOYS AND BOATS AT ROCKPORT, William Persa, pastel on Ersta 7/0 sanded paper, 11" × 14". Collection of the artist.

Persa often does very intricate work, and this can be seen in his pastel of a group of boats. He places two colorfully clothed boys in the boats to draw the eye to a strong focal point and unify all the diverse elements of the composition.

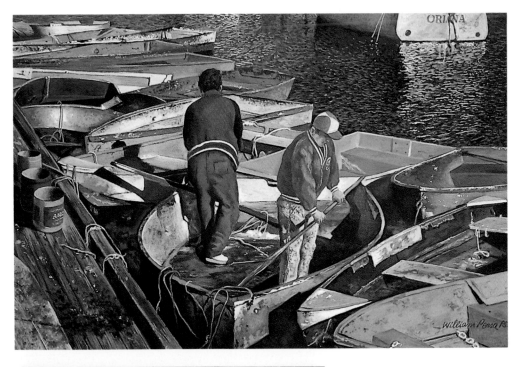

SUNDANCE I, Judy Pelt, pastel on sanded board, 30" × 22". Collection of the artist.

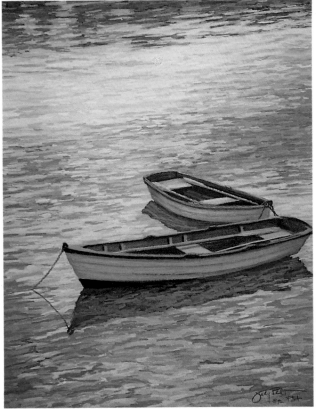

CONCLUSION

Pastel is my personal artistic statement—it captures images and feelings in textural living color. Whether using pastel to work directly on paper or to sketch the drawing and color of a scene, or translating it into an underpainted and layered composition in the studio, pastel is without equal. It is easily correctable, so you can always change your mind.

Working with pastel is exciting and adventurous. Try working with some of the black-and-white photographs in this book, or try some of your own photos. Work along with the artists. Experiment and learn about the matchless color and easy immediacy of the beautiful medium of pastel. It is my dream that you have found beauty and inspiration within these pages that will translate into your making the best pastels you have ever done. I wish you artistic excellence, warmth, love and beauty, and an appreciation for the value of your own work.

RHINEBECK ANEMONES
Madlyn-Ann C. Woolwich, 18″ × 24″

Rhinebeck Anemones is a dramatic, tactile pastel of an unusual flower. The analogous colors, wide range of different varieties, and ruffled emerald leaves make a luminous, high-key portrait that blends harmoniously with the warm lavender background.

THE ARTISTS' SUGGESTIONS
Painting and Drawing in Pastel

1. Work with the best materials.
2. Save your work when possible so you can check your progress.
3. Plan and prepare small studies.
4. Know your subject and what you want to say about using pastel.
5. Anything worth doing is worth planning—even a pastel painting.
6. Perfect placement of well-drawn elements is your final insurance for a professional job.
7. Tape pastel paper to an empty canvas. It gives the strokes a nice bounce—providing a painterly look.
8. Visualize areas of a painting before beginning, rather than through trial and error, for a finished look.
9. Pay attention to values.
10. Save details until last. Some may not even be needed.
11. Use vine charcoal for drawing, especially for portraiture.
12. Always make a complete drawing.
13. Do not layer pastel thickly. Keep work light during first stages, then apply heavily on the last details.
14. Work on colored surfaces. It is very effective and unifying if you maintain some surface color in the painting.
15. Learn to draw well. Then put just the right color and value in the right place.
16. Begin with a light touch and gradually build layer on layer to preserve the tooth of the surface.
17. Start with hard pastels and work toward softer ones.
18. When the tooth is lost in areas of the painting, sprinkle with quartz and spray with Myston (Grumbacher). Mask areas that you do not wish affected.
19. Do the layout in vine charcoal because it does not mix with color, and it is always correctable.
20. Use a circular motion to mix colors on paper.

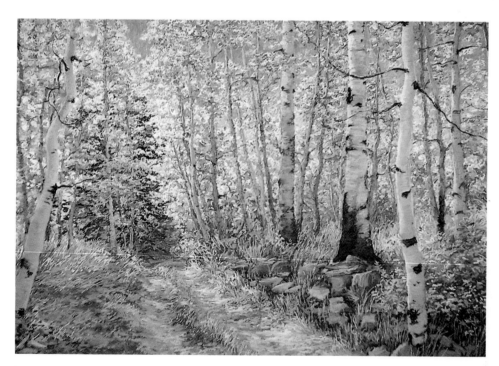

ASPEN, Judy Pelt,
24" × 36"

21. Don't give up too easily on a painting. There is usually a period of time or a dead zone that must be worked through to produce a successful painting.
22. When the tooth of a paper is full, it can be whacked on the back to shed some of the excess pastel. It should then be taken outside and sprayed.
23. To reduce flaking in the frame, give paper a good shaking before framing; for board, use a hard whack on the back.
24. Excellent drawing should come first, followed by color.
25. Avoid the use of fixative if possible, especially if your work contains many subtle changes.
26. Work from dark to light and darkest base before going to lightest colors on top.
27. Have patience in producing the foundation layers.
28. Work from diagram to shape, to form, to description and finally, to detail.
29. Rework and redraw anytime to strengthen the statement.
30. Be sure there is a contrast of hue, value and intensity in the final statement.
31. Learn to distinguish the temperature of a color and play the warms off the cools.
32. Realize that it is not necessary to tell everything about your subject . . . feel it, paint it with gusto and know when to stop.
33. Work on a vertical, slightly forward tilted surface to prevent loose pigment from sliding down over the lower parts of the painting and muddying it.
34. Hang paintings in progress on the wall so you can free your easels and still make adjustments to the painting.
35. Make new larger pastel sticks from small salvaged pieces. Use a mortar and pestle to grind them, add water and roll them out.

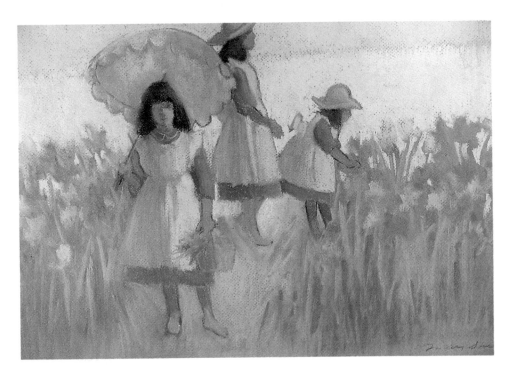

THE FLOWER GATHERERS
Mary Sheean, 20″ × 24″

YOUR STUDIO
The Artists' Tips for Keeping It Clean and Safe

1. Keep studio tidy and uncluttered. An artist should be well-organized with materials and equipment.
2. Don't allow pastel to accumulate any place on the easel, floor, etc.
3. Attach a small smoke alarm to the wall or ceiling.
4. Keep spray cans in a ventilated area.
5. Keep special tins for pastel remnants.
6. Once a pastel is begun, put all the colors you use in a separate box. It saves time rummaging for the right color.
7. Clean up completely after finishing each piece of work to establish a fresh sense of order in mind and workspace.
8. Maintain adequate ventilation, such as an open window or door.
9. Keep a vacuum handy to pick up pastel dust as it accumulates.
10. Keep work in an upright position, allowing dust to fall as you work.
11. Tap pastel to allow dust to fall; do not blow dust around.
12. Do not use sprays indoors.
13. Use the type of face mask worn by commercial painters.
14. Place an easy-to-wash cotton rug underneath the easel. It helps keep the surrounding areas clean.
15. Teach your students that they do not have to be untidy to be an artist.
16. Use track lighting to avoid the chaos of light stands and cords.
17. Invent your own method to number and organize pastel sticks for a clean studio, and to facilitate working.
18. Use a feather duster to clean pastels.
19. Place a bent piece of cardboard under the painting to catch dust.
20. Stand on a piece of carpet so pastels don't break when dropped.
21. Store loose pastels in cornmeal to keep them dust-free.
22. Avoid toxic fumes by spraying in a well-ventilated area, preferably outdoors.
23. Work with rubber or vinyl gloves or use a barrier cream.
24. Clip a large trash bag (open) over the tray of your easel to collect pastel dust. This will always be some shade of gray. Store in a jar and, when full, mix with water and a few drops of alcohol to a putty consistency. Roll out into pastels and air dry on paper towels.
25. Use a fishing tackle box to carry and/or store pastels. Use rice in each compartment to keep pastel dust down.
26. Put an ordinary large sieve or piece of screening over any messy pastels in a box. Vacuum through the mesh to remove dust.

Judy Pelt's studio has a large, custom-built pastel holder that keeps all the different shades in compartments.

Anita Wolff's working trays are sorted so that similar colors and values are combined to help organize the many kinds she uses for her work.

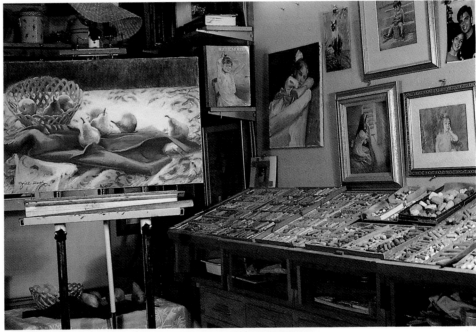

Jill Bush's studio (above) shows how organization and design can result in a beautifully planned studio. At the right side are her taboret and custom-built pastel holding trays.

This is Elizabeth Mowry's berry box (left) where she keeps most of her pastels, pencils and assorted working supplies.

CORRECTING MISTAKES
The Artists Share Their Methods

1. Brush off area with a clean brush and lightly spray with a fixative.
2. You can alternate spray and color to fasten pastel to the surface.
3. If using a pumice board, razor blade the board off. Reapply the pumice mixture in that spot and continue working.
4. Approach corrections with a light touch so you do not create a slick spot.
5. Thick buildup on Canson or similar paper can be removed with the flat side of a razor blade.
6. Sanded paper can be brushed clean with a dry bristle brush.
7. Sprinkle with quartz crystals and spray with Myston fixative to create a new surface.
8. Begin again on top of the old image if the surface is receptive. This creates an interesting myriad of colors and textures.
9. Corrections may be sketched out on a sketch pad, and the natural power of some colors can be used to make corrections.
10. Most original goals can be altered to incorporate the "mistake." This may be thought of as the painting telling you what it wants to be.
11. Minor corrections can be made by knocking off excess with a brush handle, brushing with a bristle brush or pressing firmly with a kneaded eraser and lifting gently.
12. Large areas on a gessoed board may be corrected by brushing off loose pastel, and sponging off with a damp sponge. The pastel may then be reworked.
13. If extensive corrections are needed, perhaps it is better to crop off the unwanted area.
14. Rub or hatch colors and lines together in the "mistake" area to produce a neutral color and statement.
15. Redraw your original diagram over the "mistake area" to reestablish your desired shape, form and color.
16. Lightly paint the offending area in question using matte medium with a small amount of grit (pumice) in it. This allows the restoration of a reworkable surface.
17. Turn your pastel upside down and look at it in the mirror. Sometimes the mirror will show you what needs fixing.

SUPPLIERS
Unusual Pastel Painting Materials

1. Solid Ground Pastel Panel
 Hudson Highland Artist Materials
 18 Pine Grove Ave.
 Kingston, NY 12401

2. Pumice Powder, extra fine
 Humco Laboratories
 Texarkana, TX 75501

3. Grit-Pyrotrol
 John Logan Pottery Supply and Clay Co.
 P.O. Box 122084
 Ft. Worth, TX 76121

4. Pro-Art Odorless Thinner
 P.O. Box 1417
 Beaverton, OR 97075

5. Herman Margulies Acid-Free Pastel Board
 Revere Road
 Washington, CT 06793

6. Slant Taboret
 Patrick and Jennifer O'Kelly
 317 East Devonshire
 Winston-Salem, NC 27127-3119

7. Quartz Crystals
 Exclusive Art Products
 Studio Hill Farm
 Rt. 116
 North Salem, NY 10560

8. Compressed air for correction—any computer
 or photographic supply store.

9. La Carte Pastel Card/Sennelier Pastels
 Savoir Faire
 P.O. Box 2021
 Sausalito, CA 94966

ABOUT THE ARTISTS

Larry Blovits PSA, 0-1841 Luce S.W., Grand Rapids, MI 49504. Blovits has been Professor of Art at Aquinas College in Grand Rapids for twenty-five years. He teaches workshops and exhibits nationally, and has received awards for both landscapes and portraits. Portrait commissions include presidents of universities and corporations, as well as noted professionals. "It is important for my work to be fundamentally strong, and to portray a deep statement that goes beyond mere facility with the medium."

Jill Bush PSA, 6440 Curzon Ave., Fort Worth, TX 76116. Bush considers herself a protégé of Emily Guthrie Smith (PSA Hall of Fame). She is listed in *American Art-* *ists of Renown*, with current gallery representation in Longview and Fort Worth, Texas. "My spirit is committed to the Phillipians' admonition to think of 'whatsoever things are true, honest, just, pure, lovely, and of good report' . . . and to paint accordingly."

Foster Caddell PSA, "Northlight," 1 Westerly Rd., Rt. 49, Voluntown, CT 06384. Caddell has his own private art school in Connecticut and conducts workshops in oil painting and pastel. He has written four books on painting and has been included in many books and articles. 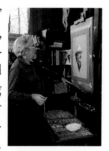 He has painted many portrait commissions. "I try to take the ordinary in life and make it extraordinary by the way I portray it. I strive for a classical timelessness."

Wende Caporale PSA, Studio Hill Farm, Rt. 116, North Salem, NY 10560. Caporale has illustrated for Reader's Digest, MacMillan and Doubleday, among others. She has exhibited in New York and Virginia.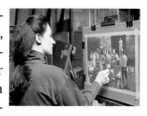

"In my work I try to create a fleeting moment of beauty. What appeals to me is the effect sunlight has on an object and the interesting cast shadows it creates."

Tim Gaydos PSA, 36 Afterglow Way, Montclair, NJ 07042. Gaydos is a freelance designer and illustrator, and teaches portraiture at the Montclair Art Museum in 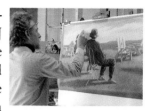 New Jersey. He exhibits in galleries in Vermont, New Jersey and New York. "I try to capture those moments in which we confront our own significance."

Bob Graham PSA, 319 Magazine St., New Orleans, LA 70130. Graham studied fine art at North Texas State University and at the Cape School of Art under Henry Hensche. His work has appeared in *American Artist* magazine. "I try to convey hard-to-express emo- tions in my art and show other people what it is like to look through my eyes."

Daniel E. Greene PSA, Studio Hill Farm, Rt. 116, North Salem, NY 10560. Greene is known as a figure, portrait and still life painter, and has recently done a series on the tile mosaics that decorate New York's subway system. He is the author of two books on pastel and has appeared in *The Artist's Magazine*. "I've always painted people, but now I have a whole new arena in which figures can interact."

Claire Miller Hopkins PSA, 515 Glendalyn Ave., Spartanburg, SC 29302. Hopkins is largely self-taught. She is a member of a number of art societies, including the 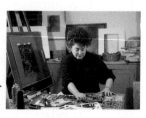 Knickerbocker Society NY, and is represented by galleries in North and South Carolina. "My art is a way of sharing what is meaningful to me."

Alan Lachman PSA, 4718 Snow Hill Rd., Cresco, PA 18326. Lachman studied at Syracuse University and

the Art Students League (NYC). He is a member of several art societies, and his work is in corporate and private collections throughout the world. "I try to freeze a moment in time through mood using spontaneity, movement and energy as my catalyst."

Elizabeth Mowry PSA, Winterset, 287 Marcott Rd., Kingston, NY 12401. Mowry, an instructor at the Woodstock School of Art, holds degrees in psychology, English literature and education, but is primarily self-taught in the field of art. She is represented by galleries in Connecticut, New York and Vermont. "I enjoy taking components of the landscape to create a composition, and then experimenting with atmospheric conditions and allowing color and my own feelings to play the dominant role of putting 'soul' in my work." Photo by Alexander Casler.

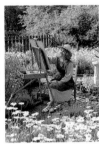

Judy Pelt PSA, 2204 Ridgemar Plaza, Apt. #2, Fort Worth, TX 76116. Pelt was selected as one of the "Texas Women" to show in the National Museum for Women in the Arts in Washington, D.C. She also shows in several galleries in Texas. "I strive to reach that 'altered state' where I lose all sense of myself and become one with my subject. Only when I sense that my heart, eyes and hand are in concert does my painting begin to live . . . the painting then becomes my celebration of life."

William Persa PSA, 4828 Scenic Acres Dr., Schnecksville, PA 18078. Persa has won over sixty national awards, and has been published several times in *American Artist* and *The Artist's Magazine*, as well as *Modern Maturity*. "I love to paint people and things related to rural living, objects showing the effects of time and use. Good drawing is the foundation of my work."

Margot Schulzke PSA, 1840 Little Creek Rd., Auburn, CA 95602. Schulzke has taught art full- or part-time over most of the western states, and cur-

rently teaches pastel and oil in Roseville, California. Her work has appeared in *The Artist's Magazine*. "I am a representational artist because of the broader range it offers in terms of composition than abstraction seems to. The subject I always paint is the play of light."

Mary Sheean, 1 The Vista, Middletown, NJ 07748. Sheean studied in Iowa and at The Art Students League, New York. She is seen in galleries in New York and New Jersey. "I try to convey a hearty acknowledgement that my work is my joy and my weapon against boredom, a measuring stick of my growth as an artist for all time."

Burton Silverman PSA, 324 W. 71st St., New York, NY 10023. To Silverman, realism isn't merely the style of his oils, pastels and watercolors, but a "mode of examining the world," of asking questions and working under the idea that "appearance and reality aren't necessarily the same." Silverman has received twenty-two awards for his works, including ones from the American Watercolor Society and the National Academy of Design. This New Yorker's paintings are in the collections of the Brooklyn Museum, Philadelphia Museum of Art and the National Portrait Gallery. He's represented by Capricorn Galleries in Bethesda, Maryland.

Anita Wolff PSA, 3116 Cedar Ravine, Placerville, CA 95667. A member of many art societies, Wolff is represented by several galleries in California and has produced two art instructional videotapes. "My earnest desire is to show through my art the feeling I have for the intrinsic charm of a given subject, and includes a love for the special appeal of ordinary and homely subjects."

Madlyn-Ann C. Woolwich PSA, 473 Marvin Dr., Long Branch, NJ 07740.

Frank Zuccarelli PSA, 61 Appleman Rd., Somerset, NJ 08873. Zuccarelli's work has appeared in *The Artist's Magazine*, and he is represented by several galleries. "I try to share my experience with the viewer. Hopefully my paintings will reveal an inner nonliteral execution of the beauty of my subject."

INDEX

Improve your skills, learn a new technique, with these additional books from North Light

Artist's Market: Where & How to Sell Your Art (Annual Directory) $22.95

Business of Art

Artist's Friendly Legal Guide, by Floyd Conner, Peter Karlan, Jean Perwin & David M. Spatt $18.95 (paper)

Best of Colored Pencil, Rockport Book $24.95

Business & Legal Forms for Graphic Designers, by Tad Crawford $19.95 (paper)

Business and Legal Forms for Illustrators, by Tad Crawford $5.95 (paper)

Clip Art Series: Holidays, Animals, Food & Drink, People Doing Sports, Men, Women, $6.95/each (paper)

Clip Art Series: Abstract & Geometric Patterns, Graphic Textures & Patterns, Graphic Borders, Spot Illustrations, Christmas, Christmas Graphics, $6.95/each (paper)

Color Harmony: A Guide to Creative Color Combinations, by Hideaki Chijiiwa $15.95 (paper)

The Complete Book of Caricature, by Bob Staake $18.95

The Complete Guide to Greeting Card Design & Illustration, by Eva Szela $29.95

Getting It Printed, by Beach, Shepro & Russon $29.50 (paper)

Getting Started in Computer Graphics (Revised), by Gary Olsen $27.95 (paper)

Handbook of Pricing & Ethical Guidelines, 7th edition, by The Graphic Artist's Guild $22.95 (paper)

How to Draw & Sell Cartoons, by Ross Thomson & Bill Hewison $19.95

How to Draw & Sell Comic Strips, by Alan McKenzie $19.95

How to Write and Illustrate Children's Books, edited by Treld Pelkey Bicknell and Felicity Trotman, $22.50

Marker Techniques Workbooks, (7 in series) $4.95 each

Watercolor

Basic Watercolor Techniques, edited by Greg Albert & Rachel Wolf $14.95 (paper)

Buildings in Watercolor, by Richard S. Taylor $24.95 (paper)

The Complete Watercolor Book, by Wendon Blake $29.95

Fill Your Watercolors with Light and Color, by Roland Roycraft $28.95

How to Make Watercolor Work for You, by Frank Nofer $27.95

The New Spirit of Watercolor, by Mike Ward $21.95 (paper)

Painting Nature's Details in Watercolor, by Cathy Johnson $22.95 (paper)

Painting Outdoor Scenes in Watercolor, by Richard K. Kaiser $27.95

Painting Watercolor Portraits That Glow, by Jan Kunz $27.95

Painting Your Vision in Watercolor, by Robert A. Wade $27.95

Splash 1, edited by Greg Albert & Rachel Wolf $29.95

Splash 2: Watercolor Breakthroughs, edited by Greg Albert & Rachel Wolf $29.95

Tony Couch Watercolor Techniques, by Tony Couch $14.95 (paper)

The Watercolor Fix-It Book, by Tony van Hasselt and Judi Wagner $27.95

The Watercolorist's Complete Guide to Color, by Tom Hill $27.95

Watercolor Painter's Solution Book, by Angela Gair $19.95 (paper)

Watercolor Painter's Pocket Palette, edited by Moira Clinch $15.95

Watercolor Tricks & Techniques, by Cathy Johnson $21.95 (paper)

Watercolor Workbook: Zoltan Szabo Paints Landscapes, by Zoltan Szabo $13.95 (paper)

Watercolor Workbook: Zoltan Szabo Paints Nature, by Zoltan Szabo $13.95 (paper)

Watercolor Workbook, by Bud Biggs & Lois Marshall $22.95 (paper)

Watercolor: You Can Do It!, by Tony Couch $29.95

Webb on Watercolor, by Frank Webb $29.95

The Wilcox Guide to the Best Watercolor Paints, by Michael Wilcox $24.95 (paper)

Mixed Media

The Artist's Guide to Using Color, by Wendon Blake $27.95

Basic Drawing Techniques, edited by Greg Albert & Rachel Wolf $14.95 (paper)

Basic Landscape Techniques, edited by Greg Albert & Rachel Wolf $16.95

Basic Oil Painting Techniques, edited by Greg Albert & Rachel Wolf $16.95 (paper)

Being an Artist, by Lew Lehrman $29.95

Blue and Yellow Don't Make Green, by Michael Wilcox $24.95

Bringing Textures to Life, by Joseph Sheppard $19.95 (paper)

Business & Legal Forms for Fine Artists, by Tad Crawford $4.95 (paper)

Capturing Light & Color with Pastel, by Doug Dawson $27.95

Colored Pencil Drawing Techniques, by Iain Hutton-Jamieson $24.95

The Complete Acrylic Painting Book, by Wendon Blake $29.95

The Complete Book of Silk Painting, by Diane Tuckman & Jan Janas $24.95

The Complete Colored Pencil Book, by Bernard Poulin $27.95

Tony Couch's Keys to Successful Painting, by Tony Couch $27.95

The Creative Artist, by Nita Leland $21.95 (paper)

Creative Painting with Pastel, by Carole Katchen $27.95

Drawing & Painting Animals, by Cecile Curtis $26.95

Drawing For Pleasure, edited by Peter D. Johnson $16.95 (paper)

Drawing: You Can Do It, by Greg Albert $24.95

Exploring Color, by Nita Leland $24.95 (paper)

The Figure, edited by Walt Reed $16.95 (paper)

Fine Artist's Guide to Showing & Selling Your Work, by Sally Prince Davis $17.95 (paper)

Getting Started in Drawing, by Wendon Blake $24.95

Getting Started Drawing & Selling Cartoons, by Randy Glasbergen $19.95

How to Paint Living Portraits, by Roberta Carter Clark $28.95

How to Succeed As An Artist In Your Hometown, by Stewart P. Biehl $24.95 (paper)

Keys to Drawing, by Bert Dodson $21.95 (paper)

Light: How to See It, How to Paint It, by Lucy Willis $19.95 (paper)

Make Your Woodworking Pay for Itself, by Jack Neff $16.95 (paper)

The North Light Illustrated Book of Painting Techniques, by Elizabeth Tate $29.95

Oil Painting: Develop Your Natural Ability, by Charles Sovek $29.95

Oil Painting: A Direct Approach, by Joyce Pike $22.95 (paper)

Oil Painting Step by Step, by Ted Smuskiewicz $29.95

Painting Animals Step by Step by Barbara Luebke-Hill $27.95

Painting Floral Still Lifes, by Joyce Pike $19.95 (paper)

Painting Flowers with Joyce Pike, by Joyce Pike $27.95

Painting Landscapes in Oils, by Mary Anna Goetz $27.95

Painting More Than the Eye Can See, by Robert Wade $29.95

Painting the Beauty of Flowers with Oils, by Pat Moran $27.95

Painting the Effects of Weather, by Patricia Seligman $27.95

Painting Towns & Cities, by Michael B. Edwards $24.95

Painting with Acrylics, by Jenny Rodwell $19.95 (paper)

Pastel Painter's Pocket Palette, by Rosalind Cuthbert $16.95

Pastel Painting Techniques, by Guy Roddon $19.95 (paper)

The Pencil, by Paul Calle $19.95 (paper)

Perspective Without Pain, by Phil Metzger $19.95

Photographing Your Artwork, by Russell Hart $18.95 (paper)

Putting People in Your Paintings, by J. Everett Draper $19.95 (paper)

Realistic Figure Drawing, by Joseph Sheppard $19.95 (paper)

Sketching Your Favorite Subjects in Pen and Ink, by Claudia Nice $22.95

Tonal Values: How to See Them, How to Paint Them, by Angela Gair $19.95 (paper)

To order directly from the publisher, include $3.00 postage and handling for one book, $1.00 for each additional book. Allow 30 days for delivery.

North Light Books
1507 Dana Avenue, Cincinnati, Ohio 45207
Credit card orders, Call TOLL-FREE
1-800-289-0963
Prices subject to change without notice.